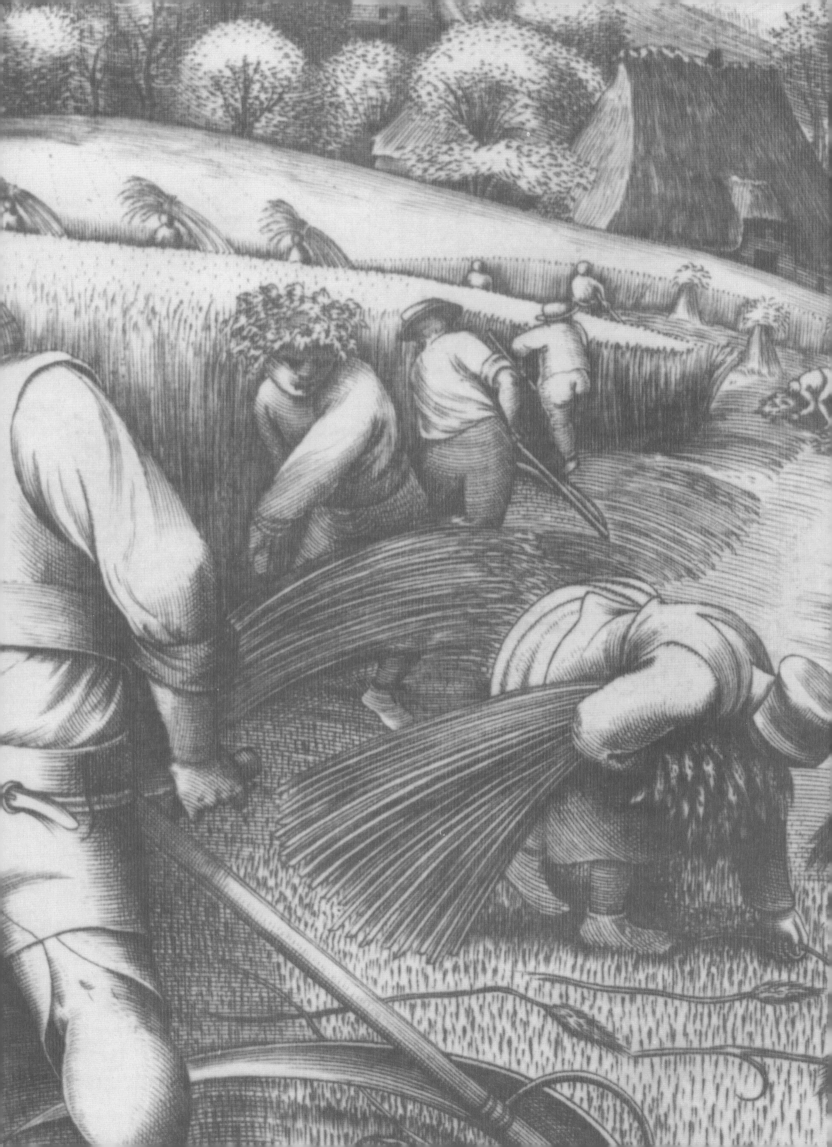

The Printed World of Pieter Bruegel the Elder

Barbara Butts

Joseph Leo Koerner

With narrative commentary by
Betha Whitlow

The Saint Louis Art Museum
April 4 - June 25, 1995

Arthur M. Sackler Museum, Harvard University, Cambridge
September 2 - November 12, 1995

cover: *Summer,* 1570
 After a drawing of 1568
 Engraving by Pieter van der Heyden
 225 x 283 mm
 Private Collection

Editor: Suzanne Tausz
Designer: Jon Cournoyer
© The Saint Louis Art Museum 1995
ISBN # 0-89178-042-4
Library of Congress Catalog Card Number 95-67195
Text "The Printed World" © 1995 by Joseph Leo Koerner

FOREWORD

The art of Pieter Bruegel has found a new place in the history of art in our generation. Bruegel has come to be increasingly seen as a figure in close touch with the wider contacts of humanism in Europe, and therefore has gained a new place as one of the most celebrated artists of his century.

The humanist movement in the sixteenth century in Northern Europe is now understood as a philosophical movement of great significance. During the past fifty years or so, we have come to appreciate the worlds of Albrecht Dürer and Desiderius Erasmus more clearly, and to view their contributions to European civilization with increasing respect and admiration. From this base, it has been possible to examine Bruegel more thoroughly, and thus we see how Bruegel built upon humanism and reinforced it by strengthening its links to the old Northern traditions that came down to him from the late Middle Ages.

Nevertheless, Bruegel, like so many other towering figures, is more than just an emblem of a philosophical movement. In his rich and varied art, we find celebration of life and land, a joyous mélange of people in all their virtue and folly, making a picture of the human condition that still moves us today.

Our authors build on this new view of Bruegel and turn their attention to his prodigious graphic output for their study. We are grateful to Dr. Barbara Butts, Curator of Prints, Drawings, and Photographs at The Saint Louis Art Museum, and to Professor Joseph Leo Koerner of the Department of Fine Arts, Harvard University, for their willingness and enthusiasm to undertake new essays on the artist from this viewpoint. This opportunity comes to them, and to us, because of an extraordinary private collection which has concentrated on Bruegel as its focus, a collection formed with a scholarly focal point over many years. The collectors knew what our scholars describe: the vast realm of human understanding and cultural philosophy that are contained in these small engravings and etchings, which themselves have been cherished and preserved by so many others in the generations since their making.

With the authors, we are grateful to Marjorie B. Cohn, the Carl A. Weyerhaeuser Curator of Prints, and James Cuno, the Elizabeth and John Moors Cabot Director, at the Harvard University Art Museums for their enthusiasm in sharing this exhibition. The exhibition was initiated by Judith Weiss Levy, previously Curator of Prints, Drawings, and Photographs at The Saint Louis Art Museum. Betha Whitlow, graduate student in the Department of the History of Art, Washington University in St. Louis, provided the commentaries for the individual prints. We appreciate the careful editing by Suzanne Tausz, catalogue design by Jon Cournoyer, and photography by David Ulmer. We express our further gratitude to David Freedberg, Lucy MacClintock, Konrad Oberhuber, Christian B. Peper, Sr., Tom Rassieur, and Timothy A. Riggs. At The Saint Louis Art Museum, we thank Elizabeth Caldwell, C.C. Fox, Tracy Hardgrove, Olivia Lahs-Gonzales, Arthur Rogers, Stephanie Sigala and the staff of the Richardson Memorial Library, Freda Stelzer, Mary Ann Steiner, Diane Thomas, and Patricia Woods.

Since exhibitions of works by Bruegel are rare at best, this marks a very special occasion for the two presenting museums. We are grateful to our team of scholars and museum professionals for their assistance in preparing this fine exhibition. And, we are most grateful to our anonymous collectors for this opportunity to present a new view of the artist's work to share with others, in the intimate form of his graphic art.

James D. Burke
Director

Humanism and Faith in the Prints of Pieter Bruegel the Elder

In 1604 the great historiographer of Netherlandish art Karel van Mander began his biography of Pieter Bruegel the Elder in *Het Schilder-boeck* (The Lives of the Illustrious Netherlandish and German Painters) by saying, "Nature wonderfully found her Man, and seized him, and then was in turn splendidly seized by him. . . ." Van Mander went on to describe Bruegel in terms evocative of François Rabelais' giants, Gargantua and Pantagruel, thus praising the gargantuan character of Pieter Bruegel the Elder and the breadth of his artistic vision.

Unlike his great northern Renaissance predecessor Albrecht Dürer, Bruegel did not engage in a lifelong study of perspective and of human and animal proportions in order to capture nature. Nor did he display the almost scientific interest in detail apparent in Dürer's famous watercolors the *Hare*, 1502, and the *Great Piece of Turf*, 1502 (both in the Albertina, Vienna). Instead, Bruegel's gift of observation is apparent in his ability to capture the vitality of both landscape and humanity in massive forms executed with broad, fluid brushstrokes. This native of the flat Flemish landscape was inspired by the Alps to reveal nature in an unprecedented breadth. In addition, he avidly recorded the breadth of human nature in scenes of the revelry and toil of the Flemish peasants and in allegories of vice and virtue. In his allegories of sin, Bruegel turned to his Flemish roots to quote Hieronymus Bosch, most strikingly his triptych, *The Garden of Earthly Delights*, c. 1500 (in the Prado, Madrid).

When and where Pieter Bruegel the Elder was born is not known. It is probable that he was born in or near Breda, near the border of Belgium and Holland, in the years 1527-28. His birth would thus coincide with the death of Dürer, who was born in Nuremberg in 1471 and died there in 1528. Like Dürer a half-century before and like most young Flemish painters of his time, Bruegel travelled across the Alps to Italy to study the art of classical antiquity and the Italian Renaissance. For Bruegel it was not so much the ruins of ancient Rome or the heroic nudes of antiquity and Michelangelo that left a lasting mark on his oeuvre, as it was the awesome views along his route and the general breadth and vitality of Renaissance art. He nevertheless used the experience of Italy to forge a thoroughly Northern style that towered above that of his contemporaries in the third quarter of the sixteenth century, just as Dürer had in the first quarter.

Bruegel was among the leading designers for the Antwerp print publishers, and although he is most appreciated today as a painter, prints are central to his artistic achievement. As David Freedberg observed, the artist's prints show "the full extent of Bruegel's great and epochmaking contribution to the art of landscape, of his detailed and devoted pursuit of the popular and proverbial culture of Flanders, of his unsparing revelations of the foolishness of human behavior, his withering satires on its vices, and his sustained and hard views of human virtue." In this essay, a brief introduction to the production of prints after Bruegel's designs and to his printed landscapes and seascapes is followed by a discussion of Erasmian thought and moral symbolism in Bruegel's depictions of peasants and in his allegorical and religious subjects.

* * * *

The story of Bruegel's prints is intimately related to that of one of the most famous printing houses in Europe, Hieronymus Cock's *Aux quatre Vents* (At the Sign of the Four Winds), so named because it aimed to disseminate prints to all corners of the earth. Cock (c. 1510-1570) employed professional engravers and etchers to reproduce Bruegel's drawings. The artists Jan and Lucas van Duetecum, Pieter van der Heyden (Petrus a Mercia), Philipp Galle, and Frans Huys collaborated with Cock and Bruegel. After Bruegel's death, his compositions were translated into prints by Joris Hoefnagel, Pieter Perret, and Philipp Galle for circulation to a wide public. In the seventeenth century, Lucas Vorsterman (1595-1675) and Hendrik Hondius (1573-c. 1649) were still producing engravings and etchings based on Bruegel's compositions.

The exact method by which Bruegel's drawings were translated into engravings and etchings is not known. The process probably involved intermediary drawings and an elaboration of details by the printmaker. Christopher White noted that Bruegel's drawing *Alpine Landscape: Study for "Rustic Solicitude"* (in the British Museum, London) is covered with black chalk on the verso, presumably indicating that it was traced for transfer to a second sheet. White also cited a drawing in the Louvre which he asserts could represent the next stage in the process. It repeats Bruegel's drawing, with additions that appear in the print: people, horses, cattle, sheep, and sailing boats as well as the tall trees in the foreground. The Louvre sheet, as White suggested, may have served the engraver of *Rustic Solicitude* (cat. 7) as a working drawing. Even less is known about the hand coloring of Bruegel's prints during his lifetime. Colored prints are rare (cat. 54), although records indicate that they were four to five times more expensive than uncolored impressions.

Many of the prints after Bruegel's drawings were published between 1555, four years after he entered the Antwerp Guild of St. Luke as a painter, and 1563, the year he married Mary ("Mayken") Coecke. Mary was the daughter of Pieter Coecke van Aelst (1502-1550), the man to whom Bruegel is reputed to have been apprenticed. In 1563 Bruegel moved to his wife's hometown, Brussels, in order, van Mander suggested, to forget the young girl with whom he had "kept house" in Antwerp. But it is just as likely that aristocratic Brussels, the residence of Margaret of Parma and her court and of Cardinal Granvelle, may have offered the prospect of important commissions. Van Mander reported that shortly before Bruegel's death in 1569, the magistrates of Brussels commissioned him to execute a series of paintings commemorating the completion in 1560-61 of the Willebroek Canal linking Brussels and Antwerp. Certainly in the 1560s commissions for paintings demanded more of Bruegel's attention and his output of prints became more sporadic. Bruegel did send a few drawings back to Cock, and prints after his drawings and paintings were also published by other firms. Even after his death in 1569, Bruegel's compositions continued to be reproduced and his earlier prints reprinted by Cock's widow, Volcxken Diericx, after the publisher's death in 1570.

Although woodcut would have rendered a greater number of impressions than engraving or etching, it seems not to have proved workable to Bruegel and Cock for reproducing Bruegel's drawings. Just one woodcut, *The Masquerade of Ourson and Valentin* (cat. 58), survives, along with a partially cut woodblock of *The Wedding of Mopsus and Nisa* (in The Metropolitan Museum of Art, New York; cat. 59). Unlike during the age of Dürer, woodcut was far less the medium of choice than engraving or etching. Perhaps Bruegel and Cock could not find the skilled *Formschneider* whose job it was to cut the woodblocks.

Only once did Bruegel execute his own print rather than entrusting the transfer of his drawing to the copper plate or woodblock by another artist. In 1560, about the midpoint of his collaboration with Cock and *Aux quatre Vents*, Bruegel drew *The Rabbit Hunt* (cat. 1) directly on a copper plate. Here we see a mobile line that parallels the freedom of execution of Bruegel's paintings, and shows the artist fully aware of the merits of etching. With light and varied touch, Bruegel scratched away the waxy or resinous covering of his copper plate. The resulting lines—when etched, inked, and printed—created a delicate tonality and atmospheric effect reminiscent of Bruegel's drawings of mountain landscapes made on the journey to and from Italy. A suggestion of movement pervades even the details. One can almost sense the eager dog wagging

its tail at the side of the hunter with a crossbow, the imminent release of an arrow, and the alertness of the grazing rabbits. The figure of the soldier stalking the hunter, and the blasted tree in the foreground, introduce a mood of foreboding into the sunlit landscape. Certainly Bruegel raises doubts about who is the hunter and who is the hunted. *The Rabbit Hunt* has been interpreted by Philipp Fehl in terms of the proverb "Who hunteth two hares loseth the one and leaveth the other." The Dutch scholar Desiderius Erasmus, who published the proverb in his *Adages*, commented that he who reached out at the same time for a double advantage would be doubly disappointed.

Only once did Cock reproduce with his own hand a drawing by Bruegel. Perhaps the first result of the collaboration between Bruegel and Cock, *Landscape with the Temptation of Christ* (cat. 3) is based on a drawing that Bruegel presumably did in Rome in 1554 of a forest landscape with five bears (in the National Gallery, Prague). Cock substituted a New Testament scene (Luke 4:1-4) for the bears in Bruegel's drawing. Apparently neither Bruegel nor his publisher were troubled by the transposition of Christ from a wilderness to close proximity with an inhabited region (the German artist Hans Lautensack had done the same in an etching of 1554). *Landscape with the Temptation of Christ* is rendered with a sensitivity to light and atmosphere apparent in Bruegel's drawing. This sensitivity stems in part from Cock's tremulous etched lines. As has been noted in the literature, the print clearly shows Bruegel's indebtedness to the Venetian landscape artists Girolamo Muziano (1528-1592), Titian (c. 1490-1576), and Domenico Campagnola (1500-1564). *Landscape with the Temptation of Christ* and related drawings in turn influenced a whole school of painters who depicted forest interiors in the Netherlands in the following two generations. The print, which might have been preserved in an album or tacked to a wall, is both an object of meditation and a beautiful view of this world.

Bruegel began his journey to Italy between the autumn of 1551 and the spring of the following year, arriving in southern Italy by the end of 1552. Upon his return to Antwerp, Bruegel's studies of the Alps were incorporated into *Weltlandschaften* (cosmic landscapes) of unprecedented breadth. The genre of landscape had not before been exploited in Netherlandish prints, although the German artists Albrecht Altdorfer (c. 1480-1538), Augustin Hirschvogel (1503-1553), and Bruegel's contemporary Hans Lautensack (1524-1566) had produced many etched landscapes. Bruegel and Cock produced a series of twelve *Large Landscapes*, several of which are included in this exhibition (cat. 4-9). The even more monumental *Large Alpine Landscape* (cat. 10) recalls van Mander's comment in the treatise *Foundation of the Painters Art*, 1604, that Bruegel successfully suggested "how

one looks down into dizzying abysses, at steep crags, cloud-kissing pine trees, vast distances, and rushing streams." The panorama that stretches into the distance behind a precipitous incline in Bruegel's print is heir to the landscape at the bottom of Dürer's engraving *Nemesis*, 1501-02 (Figure 1). But the drop in *Large Alpine Landscape* is more dizzying, due to the rugged asymmetry of the composition. And while Dürer implies his presence and vantage point in the form of a plaque with his monogram, Bruegel allows the viewer to experience the vista through the eyes of a traveler on horseback. Or, the viewer may experience the towering heights of the Alps through the awesome balance of the mountain goats on the narrow boulders at the lower right of the composition above the artist's signature.

Upon his return from Italy, Bruegel's observation of nature gradually gave way to formulas for pictorial organization which recalled the early sixteenth-century landscapes of the Netherlandish painter Joachim Patinir. The schematic mountains of Patinir's landscapes of 1515-24, little more than rocks blown up to a huge scale, are still somewhat apparent in Bruegel's *The Penitent Magdalene* (cat. 6), one of the twelve *Large Landscapes* created around 1555-56. The composition also reverts to the archaic device of sequential narrative, in which more than one event in a story is shown in one picture space. Mary Magdalene was identified in the Gospel of John (11:2) as

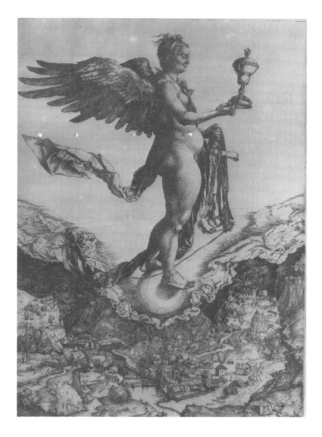

FIGURE 1
Albrecht Dürer, German, 1471-1528.
Nemesis (*The Great Fortune*), 1501-02.
Engraving; 329 x 224 mm.
The Saint Louis Art Museum.
Purchase 32:1926

the sister of Martha and Lazarus of Bethany; the western Church equated her with the repentant sinner who anointed Christ's feet (Luke 7:36-50), while legend held that in later life she lived as a penitent in retreat in a grotto at Sainte-Baume in France. In Bruegel's print the penitent Magdalene is shown reading her Bible in the foreground and elevated by angels above. Eyes accustomed to the sequential narratives of late medieval art would have had no trouble winding through this landscape, guided by a river, mountain passes, a traveler with two packmules, and a pattern of alternating light and dark planes.

The landscape drawings from Bruegel's trip to Italy proved extremely popular and continued to be reproduced after his death. Published as late as 1580 by Joris Hoefnagel (1542-1600), *River Landscape with Mercury and Psyche* (cat. 2) was apparently based on a drawing made by Bruegel in Italy in 1553. Known only from what appears to be a copy (in the Musée des Beaux-Arts et d'Archéologie, Besançon), the drawing was elaborated in the print with the engraved figures of Mercury and Psyche. It thus illustrates a late antique fairy tale told by Lucius Apuleius (2nd century A.D.) and in Ovid's *Metamorphoses*. Renaissance humanists treated the story of the beautiful maiden Psyche, who was carried to heaven by Mercury and married to her lover Cupid, as an allegory of the union of the Soul (Psyche) and Desire (Cupid). Since the story represents the transformation of body by spirit, the figures, which do not appear in Bruegel's drawing, may have been added by the publisher as a tribute to the deceased artist. The inscription on the print implies that art, like the spirit, is immortal. At the left, two artists are perched above the banks of a river. They are sketching, focusing perhaps on a boat being towed or fields being plowed, and rendering permanent these passing events of daily life.

Just as they found an avid market for landscape prints, Bruegel and Cock met with success in the publication of a series of seascapes and sailing vessels, engraved for the most part by Frans Huys. The most spectacular of these prints is the monumental *Naval Battle in the Strait of Messina* (cat. 11). Published in 1561, the work was engraved by Huys on two copper plates and recalls a painting by Bruegel, *The Battle of the Bay of Naples* of about 1552-54 in the Galleria Doria Pamphili in Rome. The engraving also records an event of nine years earlier which Bruegel may have witnessed, the threat posed to various coastal towns and cities of southern Italy in 1552 by a marauding Turkish fleet. Bruegel's engraving depicts the burning of the city of Reggio in Calabria and was apparently composed, characteristically, from a number of studies of towns and ships, including a view of Reggio now in the Boymans-van Beuningen Museum in

Rotterdam. It has been noted that Bruegel's ambitious composition, with battleships dominating the foreground and a harbor in the distance, recalls cartoons by Jan Vermeyen of 1546 commemorating Charles V's recapture of Tunis from the Turks in 1535. Bruegel's future father-in-law, Pieter Coecke, is thought to have assisted Vermeyen with those cartoons.

It is not surprising that the sea captured the imagination of the public in Antwerp at this time. The city was the busiest port in northwestern Europe at a time when shipping was rapidly replacing overland trade routes after the "discovery" of America in 1492 and the successful circumnavigation of the globe by Ferdinand Magellan in 1519-21. The establishment of sea routes to India and the New World helped to shift the center of European trade from landlocked Nuremberg to Antwerp. Along with privileges accorded by the Holy Roman Emperor Maximilian I (reigned 1493-1519), Antwerp's many fairs, and Flanders' thriving agriculture and industry, the growth in sea trade made the city the chief commercial center of Europe. Antwerp drew merchants and bankers from England, Spain, Italy, Portugal, and Germany; the great Augsburg banking houses of Fugger and Welser, for instance, were established there by 1510. At the height of her prosperity from 1517-66, Antwerp was the center of a great network of trade that extended from the Americas to China and from the Mediterranean to the Baltic.

Sea trade was not without major risks, however, to financial investments and to lives. Inscribed "this ship 1564" and probably published in 1565, Bruegel's print *A Dutch Hulk and a Boeier* (cat. 12) shows in the right foreground a corpse, which demonstrates the perils of life at sea. Stories and figures from antiquity were also revived to comment on the dangers of the sea as in *Three Caravels in a Rising Squall with Arion on a Dolphin* (cat. 13), engraved by Frans Huys. Arion's rescue by dolphins was recounted by the Greek historian Herodotus: Returning to Corinth from a musical contest in Sicily where he had won many prizes, Arion was robbed by the crew of his ship. Before throwing him overboard, the sailors allowed Arion to play his lyre once more. The poet was saved by a school of dolphins attracted by his song and the music of his lyre. In Bruegel's print, Huys' precisely engraved lines create a feeling of desolation; so too do the sailors scaling the masts of the ships, dwarfed as they are by the vessels and by the sea. The more learned of Bruegel's audience might have recognized an emblematic meaning in the image of Arion riding a dolphin. In the 1531 edition of an emblem book by Andrea Alciati, a woodcut of the subject by the German artist Jörg Breu the Elder is accompanied by the Latin motto IN AVAROS, VEL QVIBVS MELIOR

CONDITIO AB EXTRANEIS OFFERATUR (Against the covetous, or, by what strangers succor is offered). Alciati's popular *Emblemata* was published by the Antwerp press of Christopher Plantin in 1565, 1566, and 1567.

<p style="text-align:center">* * * *</p>

For Bruegel and his contemporaries, everyday life no less than ancient history was invested with moral lessons. The second part of this essay is devoted to Bruegel's allegories, his depictions of the peasantry, and his religious subjects, all of which reflect Erasmian thought and moral symbolism.

Bruegel's conscious rejection of the Italian heroic manner and his return to the Netherlandish past of Lucas van Leyden and Hieronymus Bosch must have made him look "comfortably old-fashioned" to his contemporaries, as A. Hyatt Mayor noted. Mayor continued, "He was, however, up to the minute in his friendships with mathematicians and cartographers, from whom, perhaps, he got his lofty view of man's brief swarming on this little planet spread out like a map." In fact Bruegel was a member of the most educated and urbane circles in Antwerp, counting among his friends and admirers such luminaries as the geographer and cartographer Abraham Ortelius and the poet and moralist Dirck Volckertszoon Coornhert. Bruegel belonged to a circle of humanists who have been described as "moderate Erasmian Catholics." They shared a belief in tolerance (within Christian limits) and practiced moderation and stoicism at a time of religious and political strife. In this they owed much to the Netherlandish humanist Desiderius Erasmus (c. 1466-1536, Erasmus of Rotterdam), whose portrait was issued in two engravings by Cock in 1555.

As a member of Antwerp's intellectual circles, Bruegel would have been very familiar with Erasmus' *The Praise of Folly*, and he employed, as Carl Gustaf Stridbeck observed, a similar "dualism of burlesque humor and philosophical thoughtfulness." First printed in 1511, *The Praise of Folly* appeared during the author's lifetime alone in thirty-six editions in eleven cities including Paris, Lyons, Strasbourg, Venice, Florence, Basel, Cologne, Deventer, and Antwerp. The humanist's tolerant attitude and his faith in education and reason contrasted starkly with the Protestant Reformer Martin Luther's conviction of the total corruption of man, who is saved solely by the mercy or grace of God. A tone similar to that of Erasmus pervades Bruegel's art. More specifically, Erasmus' views on folly and madness, manners and virtue are reflected in the work of Bruegel, as is the Dutch humanist's engagement with proverbial wisdom and his rev-

erence for the word of Christ, whom he considered the wisest of all philosophers. Erasmus' aim to educate man to Christ not only incorporated the Scriptures (he expressed the wish that they be translated into each and every language) and the wisdom of Christian antiquity (he published the writings of Saint Jerome in nine volumes) but also recognized the moralists of the ancient world as part of a great body of learning completed by the revelation of God in the Gospels. It was in fact Erasmus' *Adages*—which eventually contained more than 4000 proverbs collected from ancient writers in Latin, Greek, and Hebrew—that established his reputation as the leading scholar in northern Europe. While Erasmus did not publish popular sayings in the vernacular (his *Adages* did include some popular, national figures of speech translated into Latin), he was a leading figure in the passion for proverbs that pervaded sixteenth-century Europe and as such is an essential element in the art of Bruegel, which gave unprecedented visual expression to proverbial wisdom.

The nature of Bruegel's political and religious views is not entirely clear. Van Mander reported that some of Bruegel's drawings were "all too biting and satirical; and so as he lay dying he had them burnt by his wife, either through sorrow or because he feared that she might suffer as a result of them, or be held responsible for them." This would imply perhaps that the artist made drawings that expressed dissident views at a time when many in the Netherlands opposed their Spanish sovereign, Philip II. But such a view would seem to be contradicted by the fact that Bruegel's patrons included no less a distinguished politician than Antoine Perrenot de Granvelle, Archbishop of Malines (Mechlin), President of the Netherlands Council of State and advisor to Margaret, Duchess of Parma, the regent of Philip II in the Netherlands.

By the time of Bruegel's birth, the Spanish Hapsburgs had through marriage acquired control of the Low Countries. And it was the Low Countries upon which they depended for a considerable part of their revenue. After Philip II succeeded his father Charles V as ruler of the Netherlands in 1555, he reissued and strengthened his father's edicts against heresy, giving strict instructions to his half-sister Margaret and Cardinal Granvelle that they be enforced. Resistance to Philip II's rule was also exacerbated by his attempts to establish a centralized government for the independent provinces, by his reorganization of the Netherlands Church in 1561, and by his employment of foreign mercenaries. When opposition to Spanish rule escalated into open revolt in 1566, Philip II sent the Duke of Alva with Spanish and Italian troops to savagely put down the rebellions. Alva was determined to root out not only heresy and sedition but all opposition. Wholesale executions resulted; in all 12,000 persons

were prosecuted and punished for taking part in the 1566 rebellions. The brutal events of 1566-70 were recorded by Frans Hogenberg (c. 1538-1590), a Flemish contemporary of Bruegel, in twenty historical prints (*Geschichtsblätter*) first published in 1570.

Like Erasmus, Bruegel expressed his opinions on the world of his day by means of proverbs; and like Erasmus he brought his talent as a satirist and exceptional command of style, in this case visual rather than literary, to bear on moral issues. The collecting of literary proverbs was a passion among Renaissance humanists throughout Europe. Erasmus asserted that since Christ had a particular fondness for proverbs, they should command our veneration. The Antwerp press of Christopher Plantin (c. 1520-89), which published classical authors, French and Flemish texts, Bibles, devotional handbooks, liturgical books for the Spanish church, scientific treatises, dictionaries, atlases, herbals, and emblem books, also produced large numbers of collections of proverbs, incorporating Erasmus' adages with popular sayings and maxims. Proverbs were illustrated in tapestries, on the misericords of choir stalls, and on wooden plates and maiolica. They were also the material of the chambers of rhetoric (*rederijker kamers*), which performed allegorical plays as well as farces, the latter often based on village life. The chambers of rhetoric organized the allegorical floats for annual religious processions and probably the triumphal arches for the entries of visiting royalty. Drawing their members chiefly from the middle classes, they reached the height of their influence in Bruegel's day (Cock was a member).

In the visual arts, Bruegel was unrivalled in his ability to give expression to the kind of popular wisdom known to all social classes and, at the same time, to provide a game of identification for a learned audience. Bruegel's *Everyman* (cat. 40), for instance, in its references to popular, biblical, and ancient wisdom contained imagery familiar to a broad range of viewers. The tug-of-war at left would have suggested the popular proverb "Everyman pulls for the longest piece." Everyman's greedy search for goods might lead the viewer to recall Christ's parable of the sower (Matt. 13:3-23), in which the eternal word of God is lost before "the worry of the world and the deceitfulness of riches." But Bruegel also contrasts Everyman with the Greek philosopher Diogenes who, extolling the virtues of a simple life and condemning the corruption of his contemporaries, lived in a tub and went in search of an honest man. The inscription of this print, probably engraved by Pieter van der Heyden after a drawing of 1558 in the British Museum, warns that there is no one who does not seek his own gain everywhere. In the background, a picture of a fool looking in the mirror bears the inscription "Nobody knows himself," a play on the Socratic injunction "Know thyself." The

more learned of Bruegel's audience would have known that Erasmus, in the *Handbook of the Christian Knight*, called the injunction the crown of God-given knowledge. They would also have been aware of Erasmus' discussion of the saying in the *Adages* as a commendation of "modesty and a middle way." Erasmus stated, "For every evil comes from this, that everyone flatters himself, and just as he detracts from others unjustly, so he attributes more than he deserves to himself, through the vice of self-love. . . ." Everyman was familiar to Bruegel's audience as the subject of morality plays in the Middle Ages; his print is thought to have influenced a series of floats in the procession celebrating the Feast of the Assumption in Antwerp in 1563.

Bruegel's interest in Erasmian moral symbolism is perhaps most apparent in his treatment of the life of the peasant. There is little basis for the legend that Bruegel was of peasant stock. But one would like to believe van Mander's lively report that Bruegel returned to the countryside with his close friend and patron, the Nuremberg merchant Hans Franckert, to take part in peasants' fairs and weddings. Bruegel's careful observation of the peasants is reflected not in a rendering of individual physiognomies but of characteristic expressions, movements, and shapes. In fact van Mander tells us that Bruegel was admired for his ability to capture in his depiction of peasant men and women "the very nature of their rusticity, in dancing, walking, standing still, and moving in different ways."

Among Bruegel's most famous paintings are the *Months of the Year*, executed in 1565 for the banker and royal official Nicholas Jonghelinck of Antwerp, who also owned works by Dürer and a series of paintings depicting the Labors of Hercules by the leading Flemish "Romanist" of the day, Frans Floris. Bruegel's *Months of the Year* refer to the tradition of late medieval calendar illumination in which the labors of the peasants mark the passage of the seasons. *The Book of Hours of the Duke of Berry* (*Les Très Riches Heures*; in the Musée Condé, Chantilly), illuminated by the Limbourg Brothers in 1416, is perhaps the most famous example. With Bruegel however, a vernacular subject appropriate to manuscript illuminations is deemed worthy of treatment on a scale previously reserved for classical and biblical subjects. *The Months of the Year* are echoed in the artist's graphic work in *Spring* and *Summer* (cat. 47 and 48), engraved by Pieter van der Heyden after drawings of 1565 and 1568 (in the Albertina, Vienna and Kunsthalle, Hamburg respectively). *Spring* and *Summer* were published by Hieronymus Cock in 1570, the year after Bruegel's death, along with *Autumn* and *Winter* (cat. 49 and 50), which were engraved by van der Heyden after drawings by Hans Bol. In these late works there is an Italian Renaissance grandeur and strength to Bruegel's human sub-

jects; Stridbeck recognized that the pose of the thirsty peasant in *Summer* was that of the prodigal son in a print of 1545 by Cornelis Bos after the Romanist Maerten van Heemskerck (1498-1574). Bruegel audaciously invests the unsophisticated peasants with the same vitality that he perceived in the Alps.

Bruegel's *Summer* is a clear celebration of peasant labor. Bent in toil and engrossed in their work, the peasants are yet graceful and godlike. A laborer at left is crowned with a wreath as though he were a follower of Bacchus, the god of wine, vegetation, and fertility. A woman at right literally becomes the fruits and vegetables provided by her industry. The thirsty peasant in the foreground, momentarily resting from his toil in the hot August sun, is an abandoned giant of Rabelaisian proportions whose foot and scythe burst through the picture plane. His coarseness and lack of manner contrast with the ordered movement of those still working the harvest. Bruegel seems to tell us that the peasant is made beautiful by the skillful and rhythmic execution of physical tasks. The ordered landscape with church in the background suggests a world in which each person happily pursues his role with a moderation not shared by the thirsty peasant. In fact, the overall composition—including a wheat harvest, a church in the background, a farmer in the foreground harvesting wheat with a scythe, and a woman bearing food—is recognizable in an emblem of thriftiness and care for the future published by Coornhert.

The element of comedy is by no means a small one in Bruegel's treatment of the peasant. His audience was surely amused, as we are, by the artless posture of the thirstily drinking peasant or the woman whose head is transformed into a basket of vegetables. But this humor seems good-natured, and the monumental proportions and physical abandon of the figures make them anything but pitiable. While Bruegel gives visual expression to the views of a hierarchically ordered society in his praise of the *working* peasant, he also expresses in *Summer* a sympathy for the peasant akin to Erasmus' assertion in *The Praise of Folly* that those are happiest who are closest to nature.

Such a sympathetic understanding of the peasant is also apparent in Erasmus' popular treatise, *Manners for Children*, first published in Basel in 1530. Incorporating folk wisdom in the form of proverbs, maxims, and fables, the treatise was dedicated to the child of a noble protector of the humanist. In it Erasmus observed: "Those whom fortune has made plebeians, humble folk, or even peasants must strive even harder to compensate by means of good manners for what chance has denied them in the way of advantages. No one chooses his country or his father. Everyone can acquire virtues

and manners." Erasmus clearly placed virtue before manners when he concluded, "The rules we have just transcribed are not so essential that one cannot be a decent man without them." Particularly popular in northern France, the Low Countries, and the Rhineland, *Manners for Children* was published in at least eighty editions, including an edition in Antwerp in 1539.

As Margaret D. Carroll pointed out, Erasmus acknowledged both the "rustic simplicity and festive conviviality" of the Dutch peasant. She quotes his *Adages*: "If you look for manners of everyday life, there is no race more open to humanity and kindness, or less given to wildness and ferocious behavior. It is a straightforward nature, without treachery or deceit, and not prone to any serious vices [so much as] to pleasure, especially of feasting." Carroll connects Erasmus' praise of the Brabantine farmer forcing "the thirstiest sands to bear, and to bear wheat" to Bruegel's plowman by the shore in the painting the *Fall of Icarus* (in the Musées Royaux des Beaux-Arts, Brussels). An even more apt demonstration of Erasmus' phrase would seem to be Bruegel's celebration of the harvest in *Summer*.

Interpretations of Bruegel's representations of peasant celebrations (cat. 53-56) have diverged widely. Some have interpreted these images as part of a tradition in which the peasants were held up as boorish creatures, examples of grobian behavior to be looked down upon by their social superiors. Others have asserted that the peasant festivities were celebrated as expressions of Netherlandish heritage and independence in the years before the revolt of the Low Countries against Spanish rule. Do Bruegel's depictions of kermises, popular rural festivals held for church holidays, celebrate the "seasonal revival of native customs and ceremonies" as in the words of Margaret D. Carroll? Or do they condemn excess, folly, immorality, and antisocial behavior associated with the peasantry?

Surely the peasants are mocked in the inscription on *Peasant Wedding Dance* (cat. 56), in which the bride is referred to as "full and sweet" (i.e. pregnant). And while many inscriptions on sixteenth and seventeenth-century Dutch and Flemish prints were added by the publisher, the image itself, with the man urinating against a wall and the prominent codpieces of the lustily dancing figures, is equally mocking. Bruegel's cultured, intellectual patrons would have laughed at the many forms of folly that were depicted so penetratingly by the artist in his peasant celebrations. However, the peasant is by no means the sole representative of excess, greed, folly, and even madness in Bruegel's art.

Bruegel's *The Alchemist* (cat. 46), engraved by Philipp Galle after a drawing of 1558 (in the Kupferstichkabinett, Berlin), shows the figure in specifically Erasmian terms. In *The Praise of Folly*, Erasmus classes among the mad those who strive to turn one substance into another by means of novel, occult arts; those who deceive themselves until they have spent everything and "don't even have enough left to fire their own furnaces." In Bruegel's *The Battle of the Moneybags and the Strongboxes* (cat. 37), love of money gives rise to a far more destructive behavior than is seen in the depictions of kermises or in *Peasant Wedding Dance*. For here is not mere folly but a destructive madness, which Erasmus characterized in *The Praise of Folly* as the cause of "a burning desire for war, or unquenchable thirst for gold, or disgraceful and wicked lust, or parricide, incest, sacrilege or some other such plague. . . ."

Margaret A. Sullivan discussed madness and folly in Bruegel's painting *Mad Meg*, c. 1562-64 (*Dulle Griet*; in the Musée Mayer van den Bergh, Antwerp). The author notes the connection of Bruegel's work not only with the ideas of Erasmus but also with those of the Latin poet Horace (65-8 B.C.), who saw avarice, ambition, and the desire for luxuries as three manifestations of madness. Sullivan cites Erasmus' colloquy *The Epicure*: ". . . the brutes Nature produces are less wretched than ones brutalized by monstrous lusts. . . . These (madmen) are not drunk with wine . . . but with love, anger, avarice, craving for power and other sinful lusts far more dangerous than drunkenness from wine. . . . How many men do we see . . . that never sober up, never recover from the intoxication of ambition, greed, lust, and gluttony."

A precedent for the Erasmian commentary on folly and madness in Bruegel's oeuvre may be found in the work of Dürer. Dürer, who knew Erasmus and was invited to engrave his portrait in 1525, may also have treated the relationship of drunkenness to anger, greed, craving for power, and "the intoxication of ambition." In his *Manual of Measurement* of the same year, Dürer seems to condemn the peasants who revolted in the German Peasants' Wars of 1524-25 by juxtaposing a *Monument to a Drunkard* with a monument that he wrote was "to commemorate a victory over the rebellious peasants" (Figures 2 and 3). Dürer is implying perhaps that the peasants were drunk with anger and evil ambition. Like Bruegel and Erasmus, Dürer was not unmindful of the fact that the peasant was among the most useful members of the community, for he showed the peasant atop produce and work implements. But Dürer may have shared the view expressed by Erasmus in the colloquy *The New Mother*, first published in 1526, that the peasants who rebelled in 1524-25 were "bent on anarchy." An Erasmian abhorrence of war and plea for the *via media* would have been particularly appropriate in a manual devoted to measurement.

FIGURE 2
Albrecht Dürer, German, 1471-1528.
Monument to a Drunkard.
Woodcut in *Underweysung der Messung* (*The Manual of Measurement*), Nuremberg, Hieronymus Andreä, 1525; 205 x 304 mm (page).
The Saint Louis Art Museum. Purchase 175:1942

FIGURE 3
Albrecht Dürer, German, 1471-1528.
Monument to Commemorate a Victory over the Rebellious Peasants.
Woodcuts, on two pages in *Underweysung der Messung* (*The Manual of Measurement*), Nuremberg, Hieronymus Andreä, 1525; 205 x 304 mm (each page).
The Saint Louis Art Museum. Purchase 175:1942

The Erasmian view that folly is universal and virtue the only true source of nobility is most clearly reflected in two series of prints by Bruegel: *The Seven Deadly Sins* (cat. 22-28), engraved by Pieter van der Heyden and published in 1558, and *The Seven Virtues* (cat. 29-35), probably engraved by Philipp Galle and based on Bruegel's designs of 1559-60. In *The Seven Deadly Sins*—*Anger, Sloth, Pride, Avarice, Gluttony, Envy,* and *Lust*—Bruegel once again looks back to Bosch in the early sixteenth century. Each sin is personified by a female figure, around whom swarm Boschian monsters. Sin is shown as a virile and teeming force that transforms humans into wretched and helpless creatures. In *Lust* (cat. 28) Bruegel employs symbols already used by Bosch: the monkey as a symbol of raw sensuality; the bubble as a symbol of vanity; and the muscle shell as a symbol of lust. These prints depict metamorphoses quite different from those of Ovid, in which mortals are transformed into plants or animals or gods. Here humans

are transformed by sin and folly into monsters both laughable, as in the spread-eagled monster in *Lust*, and horrific, as in the man who has castrated himself at the lower right of the same print. The inscription reads, "Lust enervates the strength, weakens (effeminates) the limbs." The physical point of view in these prints is very high, the earth tilted improbably upward to allow Bruegel, like Bosch before him, to survey a myriad of manifestations of evil.

According to Erasmus' *The Praise of Folly*, virtue is the true source of nobility. Each of Bruegel's *The Seven Virtues—Faith, Hope, Charity, Justice, Prudence, Fortitude*, and *Temperance*—is again personified by a female figure. *The Seven Virtues*, Stridbeck asserts, reflect the ideas of Bruegel's kindred spirit (*Geistesverwandter*) Coornhert, who argued that the theoretical understanding of virtue must be accompanied by practical application. *Charity* (cat. 31), in particular, reflects an Erasmian belief in good works as opposed to the Lutheran emphasis on justification by faith in the Word of God. (Erasmus asserts in *The Epicure* that sins may be washed away by "the lye of tears and the soap of repentance or the fire of charity.") The figure of Charity, with flaming heart symbolizing the love of God, is almost lost amidst groups of the poor, the sick, the lame, and the imprisoned. And although we know that physical deformity could be treated as the subject of comedy or interpreted as a sign of evil in sixteenth-century Europe, the inscription underlines the image's appeal for empathy and warning against hard-heartedness: "Expect what happens to others to happen to you."

For twentieth-century viewers, *Justice* (cat. 32) is the most baffling of Bruegel's *The Seven Virtues*, as it focuses on images of the cruelest punishments and even tortures and omits the more moderate aspects of justice. Freedberg rightly notes of this and other works by Bruegel, "It is almost as if Bruegel has evolved a philosophy that is predicated on the ultimate ambiguity of things." Perhaps Bruegel, like Erasmus in *The Praise of Folly*, counted poverty, prison, disgrace, shame, torture, and entrapment among the evils that men inflict on each other.

There may also be ambiguity in Bruegel's *Prudence* (cat. 33) where the amassing of earthly treasures seems to contradict Christ's warning against every form of avarice and admonition to man to lay up spiritual treasures instead. The image, which on the surface asserts the wisdom of planning for the future, also suggests the parable of the rich fool whose soul is required of him on the very night that he decides to take his ease, having laid aside goods for many years to come (Luke 12:15-21). The church in

the distance is on one level a warning against the single-minded labor of storing goods in the foreground.

The admonitions and example of Christ are prominent subjects in Bruegel's art. Christ, as the foremost of all philosophers, is the subject of Bruegel's grisaille painting of 1565, *Christ and the Woman Taken in Adultery* (formerly in the Princes Gate Collection, London; stolen in 1981), and the print engraved after it by Pieter Perret in 1579, ten years after the artist's death (cat. 15). The story is told in the Gospel of John (8:2-11). The adulteress stands amidst a crowd of men who intend to stone her to death for her sin. A silent Christ writes in the dust, "He who is without sin among you, let him be the first to throw a stone at her." The hostile crowd disperses, the old men preceding the young ones. Christ says, "Woman, where are they? Did no one condemn you?" She answers, "No one, Lord." Christ says, "Neither do I condemn you. Go your way; from now on sin no more."

Bruegel portrays the depth of Christ's humanity and the moral perfection of his teachings in *Christ and the Woman Taken in Adultery*. The artist is better known for his depictions of debased sinners and Boschian monsters in his print series *The Seven Deadly Sins* and for his trenchant observation of excess in his paintings and prints of peasant celebrations. Yet Bruegel brings equal discernment to this quiet statement on sin and forgiveness. Like the Dutch humanist Erasmus in *The Praise of Folly*, Bruegel describes a world in which folly, and even madness, are rampant. Like the Renaissance humanist, he infuses his descriptions of men and manners with a wit and a vividness that were admired by his contemporaries and still appeal to us today. And like Erasmus he ultimately places his faith in education, reason, and humor to bring about the great virtue of tolerance.

Barbara Butts
The Saint Louis Art Museum

For sources and further reading please refer to page 35.

THE PRINTED WORLD

Pieter Bruegel enters the history of art as a traveler out to see the world. We meet him first on a great journey that took him from Antwerp, through Lyon, Rome, and Naples, to Italy's southernmost tip, then back again across the Alps. His earliest extant works document the furthest reaches of this tour: two drawings, signed and dated 1552, depicting landscapes south of Rome; a sketch of the Strait of Messina; and several drawings of Alpine views which, as spectacles of elevation, are the very antipodes of Bruegel's native Netherlands. Everything before is either legend or is lost. He is rumored to have come from the village of Bruegel near Breda, but no such place exists. He is said to have trained under Pieter Coecke van Aelst, an Italianizing painter in Antwerp, but the apprenticeship is not recorded, and Bruegel's art bears no resemblance to Coecke's. And at 1551, Bruegel registered in the painters' guild in Antwerp, and is documented as having been active in nearby Mechelen, but no works from this period survive. After his return to the Netherlands around 1554, Bruegel would become the great master of everyday life, the painter *par excellence* of native places, faces, practices, and beliefs. Yet his art originated in the encounter with other worlds, and in the attempt to bring these home by picturing them.

Bruegel's earliest commentators understood that his drawings done while travelling were formative of a new naturalism in art. Karel van Mander, Netherlandish painting's first great theorist and historian, reported in 1604 that Bruegel "drew many views from life" during his journey to Italy and France, "so that it is said of him that when he was in the Alps he swallowed all those mountains and rocks which, upon returning home, he spat out again onto canvases and panels, so faithfully was he able, in this respect and others, to follow nature." Bruegel was hardly the first northern artist to cross the Alps and return transformed. When the young Albrecht Dürer travelled to Venice in 1494, he did so partly to improve his art by modelling it after recent Italian achievements; the prints he produced upon his return to Nuremberg launched the Renaissance style in Germany. And from their Italian journeys, the Netherlanders Jan Gossart (1508-09) and Maerten van Heemskerck (1532-36) brought back sketches after antique art, helping thereby to create a new visual vocabulary for the North. Bruegel, however, was the first to venture south not for art but for nature. Instead of merely crossing them, Bruegel also discovered the Alps as a proper subject matter for pictures.

Van Mander frames this encounter with the natural world in appropriately naturalizing terms. To the story of Bruegel portraying views "from life" (an activity depicted in several landscapes by Bruegel, including his *View of the Tibur* print [cat. 4]), van Mander adds the figure of the artist devouring the Alps and vomiting them as pictures. The qualifying "it is said" locates this figure less in the realm of learned encomium than of popular adage. Bruegel's encounter with foreign nature, with a world never before explored by art, thus gets expressed in a comic, down-to-earth, local, and, as it were, natural language. Or more precisely, given Bruegel's fame as a painter of peasant feasts, the adage of the artist's overeating resonates with Bruegel's pictures themselves, which encompass the "natural" both as the immense otherness of landscape and as the creaturely life of common folk in their comic excesses and their proverbial wisdom. Later critics, and even some cosmopolitan sixteenth-century observers, complained that Bruegel had been to Rome but had learned nothing. His art, they argued, not only depicted rustics, but was itself rustic: at best a kind of folk painting, at worst a proof of northern backwardness. For such critics worldliness was equated with fluency in the Italian style, which by 1550 was European art's pictorial *esperanto*. Van Mander measures Bruegel on a different scale, picturing him as a Gargantua with the Alps as his banquet. Perfectly in tune with Bruegel's Rabelaisian art, and trumping any complaint about his provinciality, this image redefines worldliness as the digestion of the whole world into art.

A visit to the Bruegel room in Vienna's Kunsthistorisches Museum makes sense of van Mander's adage. The represented spaces there on display are indeed colossal. Landscape, in Bruegel's panel paintings, functions not as mere ornament or backdrop, but as an ineluctable immensity that engulfs all human actions both within the pictures and before them. Within these pictures, events appear dwarfed by their setting. Even the Tower of Babel, which Bruegel paints huge in the middle ground of one of his most famous panels, appears stunted before the immeasurably greater extension of the world behind. Before God decides to "confound their language" and "scatter them abroad upon the face of the earth" (Gen. 11:7-8), Bruegel has reached a verdict against the tower's builders: the painted panel's oblong format, demanded by the world's vast horizon, and expressing the inescapable horizontality of world *per se*, condemns to bathos a still-unified humanity intent on building a vertical tower "whose top may reach unto heaven." In front of such pictures, the viewer, too, will be gathered and eclipsed by the painted world. The epochal spaciousness of Bruegel's pictures, their unique capacity to encompass what appears as the whole of life in a single tableau, is one source of their immense popularity in our own time. The values, practices, and

beliefs assembled by Bruegel may be specific to his historical culture and therefore alien to our own, yet these all appear as babel, as child's play, as mere contingency when engulfed by a single, necessary, and indifferent world.

Bruegel's paintings induce this experience of absorption into an open universe more readily than do his prints. Originally intended to be framed, hung, and viewed in something like a modern picture gallery, the monumental panels in Vienna address us as we are, in our itinerary, offering us spectacles of a wide world observed as if through the open window of a spacious room. A Bruegel print, by contrast, was meant to be mounted into an album and examined flat on a desk. Its viewer, principally its owner, would not stand before it, as a visitor passing through a stately home or gallery, but would sit bent over it, as a scholar in his private study. Pressing close to the decorated surface of the sheet, and attentive to the tiniest marks visible to the naked eye, the connoisseur of prints would be drawn into a space fully as expressive as that of Bruegel's paintings. A modern exhibition of Bruegel's prints will, by necessity, display them framed and hung like paintings. Casual visitors will thus confront indifferent whitish rectangles within an indifferent space. For these prints to yield a world, they must first of all be brought into that special proximity for which they were constructed. I shall therefore begin neither by surveying the oeuvre as a whole, nor by mapping its disputed borders and internal divisions, but rather by narrating an itinerary through one of Bruegel's printed landscapes.

<p style="text-align:center">✳ ✳ ✳ ✳</p>

The print inscribed "SOLICITVDO RVSTICA" pictures a place of embarkation (cat. 7). At the lower right, two rustics enact the "care" announced in the picture's title. One sits hammering his scythe, exemplifying thus the solicitude or caretaking that land demands. Attentive only to his hammering, but facing in our direction, he functions formally to spread the shallow foreground forward to the picture plane, in tandem with the s-shaped path just to the left. The other rustic, meanwhile, stands gazing into the distance, propping himself with his scythe. Neither mowing nor mending, he might seem to have let his care lapse during that natural interim in rural labor so nicely expressed in the English word "whet," which denotes both the honing of a scythe and the spell of work between two honings. Momentarily withdrawn from labor, this peasant might still express rustic care in his visual contemplation of arable land as beautiful landscape. Turning from us, but sharing our view of the world, he models our own aesthetic relation to the landscape, defining it not as labor but as leisured looking. Working and watching—attitudes, respectively, of the active and contempla-

tive life—appear to face in opposite directions; but in the two trees that rise from between the rustics, Bruegel pictures their natural intertwining.

As surrogate viewer within represented space, and as exemplar of looking as itself a mode of labor, the peasant turned away serves to introduce us to the printed landscape. He mediates between our world and the world within the work, as between the urban leisure for which the print was made and the rustic solicitude that it celebrates. Of course, we need no such visual bridge to enter the valley that stretches to the sea. We will have plunged into deep space the moment we pause to contemplate the print. The peasant, however, remains behind at the periphery of our gaze, attached to the flanking, vertical forms of trees and cliffs that frame our view. Grounding us in represented space by gazing from a foreground we notionally share, he reminds us that we exist here, in this place and this body, rather than there, in the distance where our eyes roam. And he thereby relates those distances to us as places observed always from *a point of view*.

Typically, Bruegel animates the lower-right corner of his landscape prints with figures expressive of an attitude towards world. In *Saint Jerome in the Wilderness* and *The Penitent Magdalene* (cat. 5 and 6), saint and sinner convey their ascetic withdrawal by literally turning their backs to the landscape, in counterpoint to our gaze. In *Rustic Solicitude,* Bruegel seems to complement the laboring peasant turned towards us with a figure of our own absorption in the visible world. Yet because his effect is to remind us where we are, and thus to maintain us at a distance from the spectacle, the peasant turned towards the landscape expresses a particular attitude of detachment. For according to the Stoic moral philosophy championed by Bruegel's patrons, the individual ought to withdraw from the world, from its pains and its pleasures, in order to view the whole from afar. "The horse," wrote the Roman statesman and rhetorician Cicero in a passage often cited by the artist's contemporaries, "was created to draw and to carry; the ox, to plow; the dog, to guard and to hunt; man, however was born to contemplate the world with his gaze" (*De re publica* 6. 15). Man, that is, distinguishes himself from the rest of creation by his having a world view, indeed by his constituting the world *as* view. Alone endowed with the capacity both to work and to watch, he alone relates to world as a subject to mere objects.

Bruegel's prints offer us world views. They position us high above ground, and display objects and events as mere localities within an all-encompassing whole. Yet even as they celebrate aesthetic contemplation as stoic distance, or as seeing sublimated

above doing, they also lure us back into the world through the enchantment of their detail. Looking, in these prints, is ceaseless toil and travel from thing to thing. From this tree to that rock to this church spire to that other tree, the eye moves in interminable digressions guided but not controlled by natural itineraries: the roads, rivers, fields, and valleys. An individual thing becomes a place for exploration if the eye discerns an action there. The road that's travelled; the river that's forded, fished, or ferried; the field that's plowed or pastured: these are what halt the movement of the eye. In the middle ground of *Rustic Solicitude*, for example, at the precise median of the oblong printed sheet, two wanderers hurry past a wooden crucifix along the road. Their action tells a story, or enacts a moral, that, say, travelling from here to there they were admonished by the Cross. Actions fit objects into the temporal structure of an experience. They transform neutral, indifferent space into specific, valued, lived, historical places.

Although elevated above the world and leisured in its own movements, the eye seeks within the landscape evidence of action and of labor, of the visible visibly worked. Of course, since the eye travels not in a world, but in a work of art, everything it encounters will, indeed, be worked, as the product of the artist's toil. At the point where, bearing down on the print, the eye engages fully with the details of a world, it will discern the graphic marks that render world. The particular aesthetic pleasure of the print derives from the consciousness of represented things as precise notations: the tree as a stippled contour; its shaded trunk as a thin and a heavy line; the sail on the horizon as a tiny loop of ink. The discipline of these marks, their curtailment of any flourish that would suggest the movement of drawing or of etching the image, does not efface labor but gives it the character of care: care for the truth and order of appearances. Here, perhaps, we discern another valency for the two solicitudinous rustics in Bruegel's print. While the one who contemplates the landscape represents the picture's viewer, the other, industriously honing his blade, suggests the artist preparing to work the plate with etcher's needle or engraver's burin. At the image's edge, the two rustics are the Janus faces both of seeing and doing, and of art's consumption and production.

From our visual journey thus far, it should be clear how difficult it is to contemplate Bruegel's painted world as a "whole." Our eye travels among local details, discerning in each the outline of an operation or experience. The global point of view might be given in the surrogate viewer at the picture's margins. And the outline of a globe, indeed the orb of the world itself, may be indicated by the landscape's framing struc-

tures: the mountains surround the valley like the borders of the earth, and the foreground trees curve over the huge expanse like outlines of the heavenly sphere. Yet between the viewer and the limits of the globe, the world appears less in its totalized projection as *map* than as a spectacle of possible *itineraries.*

Much has been written about Bruegel's relation to Renaissance cartography. The artist's friend, patron, and eulogist Abraham Ortelius (1527-1598) was Antwerp's greatest editor and publisher of maps. Along with Gerardus Mercator (born near Antwerp in 1512), he established the Netherlands as the premier center of early modern map-making in early modern Europe. In his 1570 atlas entitled *The Theater of the World*, Ortelius issued seventy engraved maps charting the known earth. The *Theater*, as its name suggests, was meant to be both used for travel and perused for pleasure. Contemporaries celebrated how its maps could enable vicarious journeys through strange landscapes as viewed from on high.

Bruegel's landscapes, produced for the same audience as Ortelius' atlas, and viewed under the same conditions, yield similar pleasures. The river valley in *Rustic Solicitude*, which progresses to the horizon as it rises vertically on the picture plane, can be experienced like a map laid flat on a desk and observed obliquely, from a viewpoint just above its lower edge. Bruegel, to be sure, portrays individual features (trees, castles, towns, hills, etc.) frontally, in elevation, as it were, but so do many sixteenth-century maps, including those circulated by Bruegel's publisher Hieronymus Cock (c. 1510-1570). And the itineraries through the valley (roads, fields, and river), as well as the borders of the flatland at the mountains and sea, appear as if rendered in plan. In his earliest sketches made while travelling, which served as models for prints like these, the artist learned to reconcile plan and elevation by attending to alpine views. From the valley, a mountain will naturally appear in elevation, as something perpendicular to the ground and parallel to the picture. Yet the features on its slopes, tilted towards the eye, appear in plan. Similarly, valleys observed from on high will not spread forth from the eye, parallel with the line of sight, but will instead confront the eye directly, like a map of the terrain. Bruegel worked to combine mountain and valley into a seamless whole, thus reconciling both the picture plane with landscape's horizontality, and painting's traditional view *across* with mapping's view from *above.*

Scholars of cartography have traced the history of modern maps back to the representation of itineraries. Medieval pilgrimage guides tended to illustrate only the proper route for travel, not the larger space that the route traversed; and they indicated local

features for the observances to be enacted there: what to see and do, where and how to pray, etc. Even the earliest accurate coastal sailing maps, the so-called portolan charts of the fourteenth century, began as written descriptions of singular journeys taken, and they continued to foreground individual courses over the indication of a geographical whole. In the early modern period, during the "age of discovery," worlds beyond the known itineraries were encountered and charted. Yet these charts still indicated the acts that were their cause. The figurative elements decorating the map's open spaces—those outsize boats, wind gods, and exotic beasts that escape the chart's coherent plan—are perhaps the last vestiges of the itinerary. As the historian Michel de Certeau once remarked: "These figurations, like fragments of stories, mark on the map the historical operations from which it resulted. Thus the sailing ship painted on the sea indicates the maritime expedition that made it possible to represent coastlines." Over time, such fragments disappeared. The modern map, the systematic, totalizing picture of world as pure extension, will exhibit only the product of travel, not the lived process of the journey itself. Bruegel's printed landscapes suggest a different trajectory. Whilst the river valley in *Rustic Solicitude* appears fully and consistently charted, as the instantaneous picture of all locations, Bruegel saturates this chart with temporalizing actions—work, travel, trade—that orient space and make it function. Thus rustic care, indeed, joins looking with labor, distanced contemplation with effective action, and world view with lived life.

The printed world remains, in Bruegel, a habitat. Even as he publishes the wilderness of mountains and sea, and even as he suggests further territories to be discovered, he pictures those wider worlds as lifeworlds like our own, those further hills as hills again like these. Where, though, does our eye rest within this habitat? Where is it most at home? In *Rustic Solicitude*, all itineraries end at the horizon, at the little gap where the river opens to the sea. There, at the line between earth and sky, where our view from above becomes a view across, the eye can remain indefinitely. Yet there too the eye is poised for travel, which is why Bruegel raises a sail, conveying the ecstasy, the "putting out of place," which is the horizon's subjective effect. Like the travelled road or ferried river, the sailed horizon colonizes open space by staging there an action. This action is less like labor than like looking. To view the world is to dwell on its horizons in the expectation of expanding them.

Horizons are always contingent on the beholder's point of view. Unlike the explorable frontier of wilderness, or the negotiated border of states, or the objective extremity of coastlines, or the arbitrary edge of maps, horizons are the ineluctable limit of the

human subject's *own* world. Moving with us as we travel, the horizon tells us that the visible is only a small segment, or eccentric foreground, of reality. Part cause and part consequence of a new cosmology that removed man from the world's center, and of voyages of "discovery" that rendered the European world's limits permeable, the experience of horizon as at once inescapable and infinitely displaceable is characteristic of the modern world view.

Bruegel stages this experience in remarkable and diverse ways. In his landscape prints the horizon usually appears as the end of a river valley carved out of covering mountains and opening into the sea. Sometimes this opening is suggested rather than shown, as in *Soldiers at Rest*, where the shores converge at the furthest distance (cat. 9). Sometimes hills wholly block the horizon but suggest, through their contours, that the horizon will appear "around the bend" (cat. 10). Even when he provides no visual opening, Bruegel seems to be making a point about horizons, as in his prints of festive peasant life, where an enclosed space suggests an enclave of ignorance, a world, that is, blissfully unaware of horizons (cat. 55).

Bruegel's most sublime horizon appears, tellingly, in the one print both designed and executed by the artist himself: *The Rabbit Hunt* of 1560 (cat. 1). There sea and sky meet in a broken line, suggesting that the open horizon can be inaccessible to the human eye. This accords with the print's proverb: "He who hunts two rabbits catches neither." The narrowness of human possibility is demonstrated by the singularity of aim: just as the hunter can only see to shoot one rabbit, so too the viewer must accept a world only partly visible. Bruegel's graphic style, uniquely published in this one autograph etching, enhances this sense of contingency. Rather than outlining the features of landscape as stable and objective wholes, Bruegel indicates them in the diffusion of how things are actually seen. Thus trees are a blankness defined only at their fuzzy edges, the river's shore is visible only here and there, and the horizon can be erased by light. As if commenting on his one attempt, in print, at aerial perspective, which renders not only locations but also substances as contingent on viewpoint, Bruegel includes the ominous figure of the spear-bearer, who threatens the hunter from behind. Death lurks on the horizon in the gaps that show us what we cannot see.

Horizon might be defined as the range of world visible from one particular vantage point. Positioning his viewers high above ground, opening his backgrounds to the sea, and suggesting that behind every covering hill there will lie further hills and open prospects, Bruegel expands this range beyond what his Antwerp audience, used to

flatland, had personally experienced. As resting place for the gaze and as point of ecstasy, the horizon at once marks the limit of the visible world and demonstrates a law of infinite expansion: that once arrived at the limit we will discern a new horizon at which to arrive. Mid-sixteenth-century Antwerp was a rich metropolis built on trade, the movement of goods, and the maintenance of relations and alliances far beyond the experienceable world. Its ships, so beautifully portrayed by Bruegel as ingenious machines for movement, were the means for this extension; its waterways, recalled in Bruegel's many harbor views, were its places of embarkation. The maps that its cartographers designed, as well as the landscape prints that humanized those maps, published a view of the world fully compatible with the culture's controlling expectations, indeed with its "world view."

To speak of world views, of course, is to assume the contingency of vision and of thought. It is to imagine other cultures and other periods as possessing their own particular perspectives and horizons. Bruegel's spatial horizons, expressive of early modern Europe's relation to other worlds, invites us to discern, as well, his historical horizons. Having traversed one of Bruegel's landscapes along the present itinerary, having taken its world as coextensive with my own, I shall now return to the picture's material surface and view it as the product of another world. Specifically, I shall briefly recollect what kind of thing a print by Bruegel would have been within its original horizons.

* * * *

A great painting makes the dialogue with the past seem natural. As a unique object produced *by* an exceptional individual and *for* a discerning patron, it speaks to each of us in the present as if as person to person. While we cannot know what, say, Bruegel's major patron of the 1560s, Nicholas Jonghelinck, experienced before the landscape panels he commissioned, when we stand before them today in Vienna we feel ourselves addressed as the one individual for whom another individual made this single thing. The situation of a print is different. Because its producer, product, and public are all multiple, it confronts us not as an individuality, but as a social world, or rather, as the site wherein a whole society pictured and beheld what constituted a world for it.

Bruegel's prints are all collaborative efforts involving, in addition to the artist who designed them, the engravers and etchers who translated his design to the plate, the printers who made the impressions, and the publishers who financed and organized

the whole operation. One ought to put "artist" in quotation marks, for, with the exception of *The Rabbit Hunt*, all the prints attributed to Bruegel were engraved or etched by other hands. The public prized the artistry of Bruegel's engravers as highly as it did Bruegel's designs themselves. Sixteenth-century viewers took a special pleasure in observing how an original design had been transferred into print. They understood that prints were doubly mimetic, at once the imitation of nature and the translation of that imitation into the medium of line. Antwerp engravers were renowned for their cultivation of certain graphic notations—crisscrossing and parallel lines, stippling, engraved lines combined with etching, etc.—that simulated the color and light of their model and made the translations seem true. They received double the designer's fee; and they were appreciated for the sheer dexterity with which they handled line, as well as for the consistent diligence with which they executed their products. Thus when, in 1578, the poet, playwright, and political theorist Dirck Volkertszoon Coornhert (1522-1590) received from his friend Ortelius a print by Philipp Galle reproducing Bruegel's grisaille painting *The Death of the Virgin*, he reported that he "happily scanned [it] with amazement, for both its artful drawing and patient engraving" (cat. 17).

Bruegel died in 1569, nearly a decade before Galle made this print, yet Coornhert still thought of it as an equal collaboration of draftsman and engraver. And when Galle, in the 1550s, still worked directly from Bruegel's designs, as in the great series of *The Seven Virtues* for which all the original drawings survive, the engraver did not simply transfer his model line for line to the plate (cat. 29-35). Rather, translating Bruegel's delicate cross-hatching into short, parallel strokes, and eliminating altogether his model's attention to surface textures, he achieved a tenebrism lacking in Bruegel's drawings. Galle's engraved *Faith* conveys the atmosphere of Gothic church space far more powerfully than does its model (cat. 29). Some of Bruegel's etchers were more exact in duplicating the original design (e.g., Pieter van der Heyden in the *The Seven Deadly Sins* series [cat. 22-28]), while others maintained such a loose relationship to Bruegel's art that any attribution of their prints to the master seems today misplaced (Jan Wierix's suite of *Flemish Proverbs* fall into this category [cat. 43]). Indeed the term "Bruegel's prints" is rather vague, encompassing everything from *The Rabbit Hunt* through prints designed by Bruegel but engraved by others, to ones merely imitating Bruegel's subjects and manner. The term "inventor" as applied to Bruegel and appearing in numerous engravings after his designs might seem to denote his direct participation in the project. *The Big Fish Eat the Little Fish*, however, is marked "Hieronymus Bos[ch] inventor" and monogrammed by van der Heyden, yet we possess the original drawing and it has been executed and signed by Bruegel (cat. 36). Either Bruegel

copied an actual Bosch sketch for transferal to the plate or, more likely, he produced a Boschian sketch on his own, but since he did not yet command the same authority as the earlier Netherlandish painter, his publisher issued it as "Bosch." In time, the name "Bruegel," too, would become a trademark of inventiveness, and would be advertised on prints only distantly related to the master. "Bosch" and "Bruegel" thus merely named commodities of a certain kind rather than works by a certain hand.

It was the print's publisher who defined the product, manipulated the names, and controlled the relation between designer and engraver. With very few exceptions, Bruegel's prints—by which I mean the engravings and etching-engravings made during the master's lifetime after drawings by him—were published by Hieronymus Cock's Antwerp press, *Aux quatre Vents* (At the Sign of the Four Winds). By 1550 Antwerp was the center of the publishing trade in the Netherlands, and by 1570 Cock was northern Europe's leading publisher of prints. He had precursors in this trade, such as Cornelis Bos in Antwerp and Antonio Salamanca and Antonio Lafréry in Rome. The Roman houses descended from the enterprise of the Bolognese engraver Marcantonio Raimondi, who, around 1513, collaborated with the painter Raphael in publishing "reproductions" of the latter's drawings and pictorial manner.

By the 1530s, reproductive printing had become a fully commercial enterprise in Italy. Publishers acquired or commissioned drawings by famous artists, employed in-house engravers to transfer designs to plates, and organized printing on their own presses. The prints thus produced became standardized in style, quality, and subject. This was not only because of the vastly increased production volume necessary for keeping such operations profitable. It was also a function of the product itself. The general public valued prints as efficient conduits to an original. Whether that original was a known painting, an ancient monument, an exotic or familiar landscape, or a portrait, the intervening translation into printed lines had to be uniform, or indeed invisible *as* intervention, for the public to feel themselves brought before the print's real model in the world. The ascendancy of the reproductive print in the early modern period was not merely the consequence of the publishers' greater responsiveness to public demand. Rather, it was part of the process, synonymous with an emerging modernity, whereby "world" was placed as image before a public, and whereby "public" was constituted as sharing a world view.

Cock imported reproductive printing to the North. Earlier, great northern printmakers had been the artists themselves, masters like Dürer and Lucas van Leyden who supple-

mented their work as painters by designing, executing, and marketing original prints. Cock's publishing commenced with his employment, in 1550, of the Italian engraver Giorgio Ghisi (1520-1582), and with Ghisi's production on Cock's press of a monumental print after Raphael's *School of Athens*. The engraving recalls the style and subject of Marcantonio's prints, and, more importantly, introduced to Antwerp the commercial model of reproductive printmaking. In its heyday, *Aux quatre Vents* produced about one hundred prints per year, commissioning designs from over thirty artists and employing about a dozen engravers and etchers to work the plates.

Cock seems to have retailed prints from his establishment, as well as delivered them wholesale to dealers and book publishers. The variety of types of prints produced by Cock reflects his flexibility to different demands. In addition to prints after Italian paintings, *Aux quatre Vents* published antique monuments, ornamental models, portraits, genre scenes, religious and mythological subjects, contemporary historical events, and landscape views. It was in the last area that Cock was most original as publisher. And it was here that Bruegel made his debut in print.

The twelve *Large Landscapes* (c. 1555-56; cat. 4-9), together with *Landscape with the Temptation of Christ* (1554; cat. 3), reflect the artist's first designs for Cock. The brothers Jan and Lucas van Doetecum transferred Bruegel's drawings to the plate using a combination of etching (where lines are scored on a wax-covered plate which, when bathed in acid, becomes grooved where the wax is scraped away) and engraving (where lines are made directly on the plate with a burin). Soon afterwards, Cock published designs by Bruegel of allegorical subjects, such as *The Seven Deadly Sins* series (1558). Engraved by van der Heyden, these prints recollected the manner of Bosch, whose grotesque scenes of hell, sin, and temptation enjoyed great popularity long after his death in 1516. Bruegel took from Bosch his vocabulary of monsters, demons, and fantastic architecture, as well as his overall pictorial structure, which renders figures as miniature, geometricized blotches, and sets them against a vast landscape setting. Boschian, too, is Bruegel's central preoccupation with the practices and beliefs of popular culture. Whereas Bruegel's landscapes result from his travels abroad, his people and plots reflect an encounter with home. His attention to the native lore and entertainment of the Flemish peasantry (its proverbs, feasts, and revels), as well as to that quintessentially autochthonous northern painter, Bosch, served to ground his printed world in the local.

In its time, this vernacularism was both admired and censured. Bruegel's champions celebrated him as a "natural" painter, and set his artful artlessness off against the over-adornment of mainstream Italianizing artists. His critics, however, regarded him simply as crude and unmannered, and compared his rustic figures to "carnival puppets," thus refusing to distinguish his art from the peasant revels it depicted. Beyond such aesthetic judgments, however, it is tempting to regard Bruegel's prints as occupying the place of the local within the globalizing viewpoint constructed by *Aux quatre Vents*. That nativeness should be embodied by the peasantry, rather than by Antwerp's learned elite who actually purchased these prints, reflects how a global perspective estranges home.

It is hard, of course, to order Bruegel's prints within period categories. Evidence about early collecting is scarce, and suggests at most that sixteenth-century viewers grouped prints in many different ways, sometimes by artist or medium, more often by subject. Bruegel's *Large Landscapes*, issued as a set to be mounted in an album, were more likely shelved with topographic views, maps, or *naturalia* than with other "Bruegels," such as his religious prints and moral allegories. What seems characteristic of most early print collections, however, is an encyclopedic tendency, an inclination towards a total world picture as charted by maps and illustrated by prints. The impulse, then, to collect *all* of Bruegel's prints, and to view them as a comprehensive universe, would be shared between Bruegel's original patrons and modern collectors.

<p style="text-align:center">∗　　∗　　∗　　∗</p>

Even more difficult is the question of whether the period viewer saw in these prints what we see in them today. Coornhert praised *The Death of the Virgin* for its display of "signs, tears, and miserable cries," suggesting that then, as now, viewers lingered over details and entered the print through subjective empathy. Ortelius' admirers lauded his maps for the pleasures of vicarious travel they afforded; our itinerary through *Rustic Solicitude* retraced, I hope, something of that primary visual delight. And Ortelius himself, in an encomium of around 1574, wrote that "in all [Bruegel's] works more is always understood than is painted," thus authorizing all future discoveries of deeper levels of meaning beneath Bruegel's simple surfaces. Indeed works like *The Seven Deadly Sins* and *The Seven Virtues* were intended to occasion that ocean of inconclusive commentaries that now surrounds them. Yet beyond these rare generalities about feeling, pleasure, and sense that Bruegel's contemporaries sometimes documented for us, it is only the works themselves that can guide us in our response. Filled

with strange plots, foreign figures, and exotic symbols, these often face us as if from another world; and so, to familiarize them somewhat, I shall conclude with Bruegel's picture of an outlandish face.

In Bruegel's one extant woodcut, a wildman meets a king on a village street (cat. 58). Each stands identified by attributes: the king by his orb and crown, the wildman by his club, leafy garb, mad stare, long hair, and beard. The ruler over men, it seems, confronts here natural man: the "native" or "savage" who is alien to the hierarchies that constitute the social world. Yet the longer we look, the more alien these differences themselves appear. The wildman's body appears covered by something like fur, yet the regular arrangement of tufts, as well as the visible gap between these and the wildman's hands and feet, suggest a furry garment. And those round, wild eyes that peer forth from a shock of hair become, upon further inspection, eyes in a mask framed by a wig and false beard. The king, too, is exposed as masquerade. He is a peasant whose crude artifice Bruegel marks by shading the line between face and beard, and by balancing the crown like a tin can on top of a furry cap. Once recognized for what it is— mere rustic entertainment—everything in the scene falls into place. The woman to the right is faceless because she too wears a mask; the background figures collect money for the players; and the crowd in the window locates the play in the street, before a village tavern or brothel. Scholars have identified the scene as an episode from the popular Flemish play *Ourson and Valentin*, in which twin brothers, divided at birth, meet again as knight and wildman and become the king's companions in arms.

What is striking about Bruegel's woodcut is how subtly but deliberately it exposes the peasants' play. Where we thought we had encountered natural man, we discover the native peasant dressed like a "carnival puppet." And what therefore we thought was crudeness on Bruegel's part—the unadept treatment of fur, beard, eyes, and crown— turns out to be rustic artifice. This placement of the "wildman" in quotes would have been unthinkable in the art of Bruegel's precursor, Bosch, who appropriated popular symbolism without ever marking it as "popular," which is to say, as other than his own. Bruegel unmasks the wildman by exposing the seams of his outfit, as if to say that the myth of wildness is merely a myth, and indeed that Bruegel's own art is only apparently strange, foreign, and exotic.

Van Mander reports that Bruegel and his patron often "went on trips among the peasants, to their weddings and fairs. The two dressed like peasants, brought presents like the other guests, and acted as if they belonged. . . ." Whether this story is true or not,

the woodcut displays the effect of social tourism. At the same time as the wildman becomes familiarized as peasant artifice, the peasant, distinguished from the artist by the transparency of his costume, becomes strange. He becomes the native of another world *within* Bruegel's own lifeworld, the proof that strange horizons, once crossed, will make home itself seem strange. Staring out at us not as eyes but as mask, Bruegel's quotidian other bespeaks the modern conditions: world views, once pictured and published, will henceforth be plural.

Joseph Leo Koerner
Harvard University

For sources and further reading please refer to page 35.

SOURCES AND FURTHER READING

For a general introduction to Pieter Bruegel the Elder, see Walter Gibson, *Bruegel* (New York, 1977); on Bruegel's prints, see René van Bastelaer, *The Prints of Peter Bruegel the Elder: Catalogue Raisonné*, trans. and rev. Susan Fargo Gilchrist (San Francisco, 1992), and the catalogue *The Prints of Pieter Bruegel the Elder*, ed. David Freedberg, et al. (Tokyo, 1989); on his drawings, see Ludwig Münz, *Bruegel: The Drawings*, trans. Luke Hermann (New York, 1961), as well as the catalogues *Pieter Bruegel d. Ä. als Zeichner*, ed. Fedja Anzelewsky, et al. (Berlin, 1975), and *The Age of Bruegel: Netherlandish Drawings in the Sixteenth Century*, ed. John Oliver Hand, et al. (Washington, 1986). On Hieronymus Cock, see Timothy Allan Riggs, *Hieronymus Cock (1510-1570): Printmaker and Publisher in Antwerp at the Sign of the Four Winds* (New York, 1977); on early prints generally, see David Landau and Peter Parshall, *The Renaissance Print, 1470-1550* (New Haven, 1994).

For more specific information in "Humanism and Faith in the Prints of Pieter Bruegel the Elder" by Barbara Butts:

On Bruegel's date of birth see J.B. Bedaux and A. van Gool, "Bruegel's birthyear, motive of an ars/natura transmutation," *Simiolus* 7 (1974), pp. 133-56. I have quoted Karel van Mander's biography of Bruegel from Freedberg, et al., 1989. A. Hyatt Mayor is quoted from *Prints and People: A Social History of Printed Pictures* (Princeton, New Jersey, 1971). On the market for Bruegel's prints, including the relative prices paid for hand-colored impressions, see Jan van der Stock, "The Impact of the Prints of Pieter Bruegel the Elder," in Freedberg, et al., 1989.

On landscape see Lisa Vergara, "The Printed Landscapes of Pieter Bruegel," in Freedberg, et al., 1989 (from which I have also quoted van Mander's *Foundation of the Painters Art*). On landscape see also Konrad Oberhuber, "Bruegel's Early Landscape Drawings," *Master Drawings* 19 (1981), pp. 146-56 and plates 18-31; and Christopher White, "Pieter Bruegel the Elder: a New Alpine Landscape Drawing," *Burlington Magazine* 105 (1963), pp. 560, 563, and figures 45-47.

On the emblematic meaning of Arion riding the dolphin see Arthur Henkel and Albrecht Schöne, eds., *Emblemata: Handbuch zur Sinnbildkunst des XVI. und XVII. Jahrhunderts* (Stuttgart, 1967, new edition 1976). On the proverbial meaning of *The*

Rabbit Hunt see Philipp P. Fehl, "Peculiarities in the Relation of Text and Image in Two Prints by Peter Bruegel: *The Rabbit Hunt* and *Fides*," *North Carolina Museum of Art Bulletin* 9:3-4 (1970), pp. 24-35. On Hogenberg's historical prints see Fritz Hellwig, *Franz Hogenberg—Abraham Hogenberg: Geschichtsblätter* (Nördlingen, 1983).

I have quoted Margaret D. Carroll from "Peasant Festivity and Political Identity in the Sixteenth Century," *Art History* 10:3 (1987), pp. 289-314. Margaret A. Sullivan's *Bruegel's Peasants: Art and Audience in the Northern Renaissance* (Cambridge, 1994) places the artist's peasant imagery within the context of Erasmian and classical satire. Other important discussions of peasant revelry in Bruegel's oeuvre are Svetlana Alpers, "Bruegel's festive peasants," *Simiolus* 6 (1972-73), pp. 163-76, and Paul Vandenbroeck, "Verbeeck's peasant weddings: a study of iconography and social function," *Simiolus* 14 (1984), pp. 79-124. See Vandenbroeck on the concept of grobianism (from the German *Grob*: lacking in manners, coarse) and its association with folly, immorality, chaos, and antisocial behavior and on the definition of manners and culture by means of contrast with the grobian behavior of the peasants. Robert Baldwin argues persuasively in "Peasant Imagery and Bruegel's '*Fall of Icarus*,'" *Konsthistorisk Tidskrift* 55:3 (1986), pp. 101-14, that Bruegel's painting includes "a faint but unmistakable hint of contemporary social repression, the celebration of an obedient peasantry keeping to its God-given place." On the peasant heads (cat. 63 and 64) see Konrad Oberhuber, "Pieter Bruegel und die Radierungsserie der Bauernköpfe," in *Pieter Bruegel und seine Welt*, Otto von Simson and Matthias Winner, eds., prepared for printing by Ernst Kreutzer and Hans Mielke (Berlin, 1975), pp. 143-47, figures 1-12 on plates 52-57.

On the chambers of rhetoric see Walter S. Gibson, "Artists and *Rederijkers* in the Age of Bruegel," *Art Bulletin* 63 (1981), pp. 426-46. On proverbs and particularly on proverbs used to address the morality of the peasants see Sullivan, 1994 and David Kunzle, "Bruegel's Proverb Painting and the World Upside Down," *Art Bulletin* 59 (1977), pp. 197-202. See also Walter S. Gibson, "Speaking Deeds: Some Proverb Drawings by Pieter Bruegel and His Contemporaries," *Drawing* 14:4 (1992), pp. 73-77. On the learned interest in proverbs in the sixteenth century see Natalie Zemon Davis, *Society and Culture in Early Modern France* (Stanford, 1975). On folly and madness in Bruegel's work see Margaret A. Sullivan, "Madness and Folly: Peter Bruegel the Elder's *Dulle Griet*," *Art Bulletin* 59 (1977), pp. 55-66.

On Erasmus' and Luther's works see Desiderius Erasmus, *The Praise of Folly*, trans., introduction, and commentary by Clarence H. Miller (New Haven, 1979); Margaret

Mann Phillips, *The "Adages" of Erasmus: A Study with Translations* (Cambridge, 1964); Craig R. Thompson, *The Colloquies of Erasmus* (Chicago, 1965); and Martin Luther, *Three Treatises* (Philadelphia, 1970). On the Christian Humanism of Erasmus see Paul Joachimsen, "Humanism and the Development of the German Mind," in Gerald Strauss, ed., *Pre-Reformation Germany* (New York, 1972). On Erasmus and Luther see G.R. Elton, *Reformation Europe 1517-1559* (New York, 1963), pp. 61-62. Erasmus' *Manners for Children* is quoted from *A History of Private Life*, Philippe Ariès and Georges Duby, general eds., vol. 3, *Passions of the Renaissance*, Roger Chartier, ed., Arthur Goldhammer, trans. (Cambridge, Massachusetts, 1989).

The relationship of Bruegel to Erasmian thought and particularly Erasmus' *The Praise of Folly* is alluded to often in the literature, most notably by Charles de Tolnay (*The Drawings of Pieter Bruegel the Elder* [London, 1952]). The connection between Bruegel and Erasmian thought is made most convincingly in the works of Carroll and Sullivan mentioned above and in Carl Gustaf Stridbeck's *Bruegelstudien: Untersuchungen zu den ikonologischen Problemen bei Pieter Bruegel d. Ä. sowie dessen Beziehungen zum niederländischen Romanismus, Acta universitatis Stockholmiensis* 2 (Stockholm, 1956). Stridbeck also attempts to establish the relationship of Bruegel's imagery to the ideas of Dirck Volckertszoon Coornhert. He illustrates the Coornhert emblem mentioned above. For a summary of some of Stridbeck's conclusions regarding Bruegel and Coornhert see H. Arthur Klein, *Graphic Worlds of Peter Bruegel the Elder* (New York, 1963).

Dürer's monument commemorating the defeat of the peasants has been previously interpreted in terms of Luther's but not Erasmus' writings. For other interpretations see especially Hans-Ernst Mittig, *Dürers Bauernsäule: Ein Monument des Widerspruchs* (Frankfurt am Main, 1984). Mittig (especially page 45) sees the monument as one that shows concern and compassion for but not solidarity with the defeated peasants. Dürer, he asserts, criticizes the excesses but not the rights of the victors. On the monument as a celebration of order see Stephen Greenblatt, "Murdering Peasants: Status, Genre, and The Representation of Rebellion," *Representations* I:1 (1983), pp. 1-29.

For more specific information in "The Printed World" by Joseph Leo Koerner:

On Bruegel's iconography, Carl Gustaf Stridbeck, *Bruegelstudien, Acta Universitatis Stockholmiensis*, 2 (Stockholm, 1956); on Bruegel's landscapes, Justus Müller Hofstede, "Zur Interpretation von Pieter Bruegels Landschaft. Ästhetischer Landschaftsbegriff und Stoische Weltbetrachtung," in *Pieter Bruegel und seine Welt*, Otto von Simson and

Matthias Winner, eds. (Berlin, 1979), pp. 73-142, as well as Walter Gibson, *"Mirror of the Earth": The World Landscape in Sixteenth Century Flemish Painting* (Princeton, 1989); on Bruegel's reception by Ortelius and van Mander, Walter S. Melion, *Shaping the Netherlandish Canon: Karel van Mander's "Schilder-Boeck"* (Chicago, 1991), esp. pp. 173-82; on negative criticism of Bruegel in his time, David Freedberg, "Allusion and Topicality in the Work of Pieter Bruegel: The Implications of a Forgotten Polemic," in *Prints of Pieter Bruegel*, pp. 53-65; on Bruegel's peasants, Svetlana Alpers, "Bruegel's Festive Peasants," *Simiolus* 6 (1972-1973), pp. 163-76, and, more recently, Margaret A. Sullivan, *Bruegel's Peasants: Art and Audience in the Northern Renaissance* (Cambridge, 1994); on *The Rabbit Hunt*, Philipp P. Fehl, "Peculiarities in the Relation of Text and Image in Two Prints by Peter Bruegel: *The Rabbit Hunt* and *Fides*," *North Carolina Museum of Art Bulletin* 9:3-4 (1970), pp. 24-35.

Karel van Mander's biography of Bruegel (1st edition) is now available in a new English translation as *The Lives of the Illustrious Netherlandish and German Painters*, vol. 1, trans. and ed. by Hessel Miedema (Doornspijk, 1994); the quotation I cited appears on page 190. The encomia of Abraham Ortelius' *Theatrum Orbis Terrarum*, as well as Ortelius' Bruegel encomium, are collected in the *Album Amicorum Abraham Ortelius* (facsimile and French summary by Jean Puraye [Amsterdam, 1969]). Coornhert's letter to Ortelius is published in J. H. Hessels, ed. *Abrahami Ortelii et virorum eruditorum ad eundem et ad Jacobum Colium Ortelianum epistulae* (Cambridge, 1887), pp. 175-76; see also Walter S. Melion's discussion in "Theory and Practice: Reproductive Engravings in the Sixteenth-Century Netherlands," *Graven Images: The Rise of the Professional Printmakers in Antwerp and Holland, 1540-1640*, eds. Timothy Riggs and Larry Silver (Evanston, 1993), pp. 48-55.

On the relation between itinerary and map, see Michel de Certeau, *The Practice of Everyday Life*, trans. Stephen Rendall (Berkeley, 1984); on the history of cartography, see John Noble Wilford, *The Mapmakers* (New York, 1981); on the relation between landscape painting and habitat, see Jay Appleton, *The Experience of Landscape* (New York, 1975), and idem, *The Symbolism of Habitat* (Seattle, 1990); on the concept of "horizon," see Hans Georg Gadamer, *Truth and Method*, trans. Garrett Barden and John Cumming (New York, 1985), pp. 269-74; on the expanding horizon of visibility as characteristically modern, see Hans Blumenberg, *The Genesis of the Copernican World*, trans. Robert M. Wallace (Cambridge, 1987), pp. 622-43.

CATALOGUE

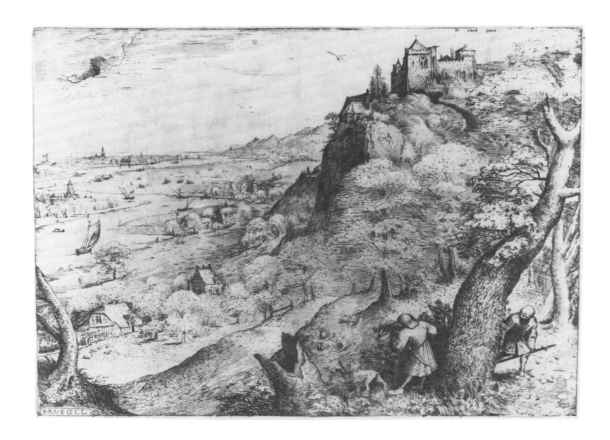

1 *The Rabbit Hunt,* 1560

Etching by Pieter Bruegel

The only etching executed by Bruegel, *The Rabbit Hunt* effectively translates his sensitive drawing technique into the print medium. Bruegel makes maximum use of the white of the paper, utilizing short strokes and dots instead of patches of light and shadow to distinguish forms and provide the treetops with the loose and airy quality that is found in his drawings. The subject, however, may be more sinister than the title implies. The ominous figure peering from behind a tree may be in pursuit of the rabbit hunter. Thus an element of suspense is introduced in an image which initially appears to be a vehicle for Bruegel's formal experiments in the print medium.

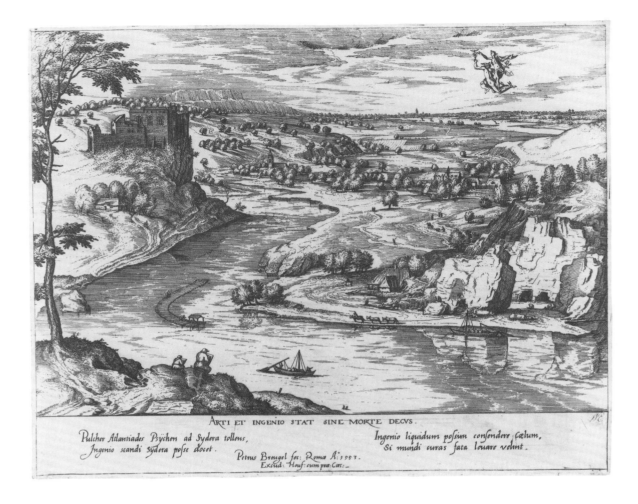

2 *River Landscape with Mercury and Psyche,* 1580 or before

After a drawing of 1553
Etching and engraving attributed to Joris Hoefnagel or Simon Novellanus

Because of his skill and invention, his honor remains deathless. Comely Mercury, by lifting Psyche to the stars, teaches that the stars can be reached through invention. Through invention I could climb the bright heavens, if the fates were willing to relieve me of the cares of the world.

This print is probably based on a Bruegel drawing obtained by the publisher Joris Hoefnagel after Bruegel's death. The landscape derives from a drawing of the Italian countryside observed by Bruegel in 1553. The figures of Mercury and Psyche do not appear in the original Bruegel design, and were in fact engraved directly onto the previously etched plate. Apparently added as an afterthought, the small figures of Mercury and Psyche would have appealed to the popular taste for landscapes which combined topography with mythological or religious subject matter.

41

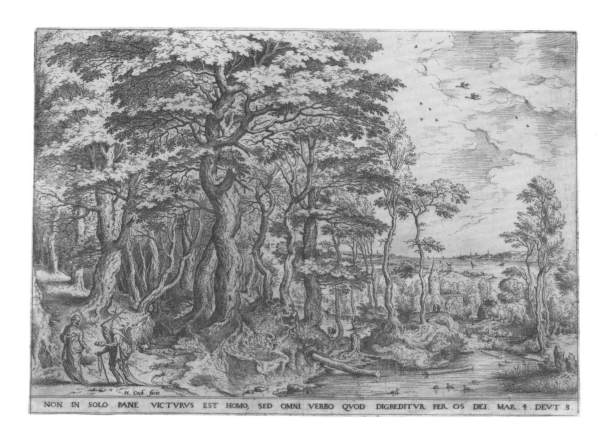

NON IN SOLO PANE VICTVRVS EST HOMO, SED OMNI VERBO QVOD DIGREDITVR PER OS DEI. MAR. 4 . DEVT . 8 .

3 *Landscape with the Temptation of Christ,* c. 1555

After a drawing of 1554
Etching and engraving by Hieronymus Cock

Man doth not live by bread only, but by every word that proceedeth out of the mouth of the Lord.
Mar. 4.Deut. 8.

Landscape with the Temptation of Christ is based on a drawing in Prague which depicts a similar landscape with gnarled trees. It is strikingly similar to the work of the Venetian landscape artists Girolamo Muziano, Titian, and Domenico Campagnola in the dense yet fluffy foliage and striking atmospheric qualities. The beautiful landscape, which has a towering verticality that reaches toward the heavens and is permeated by a radiant, natural light source, enhances the divinity of Christ. The etching also bears the imprint of Hieronymus Cock, who replaced five bears in Bruegel's drawing with the scene of Christ's temptation by the Devil, perhaps to appeal to the taste for landscapes with mythological and biblical subjects.

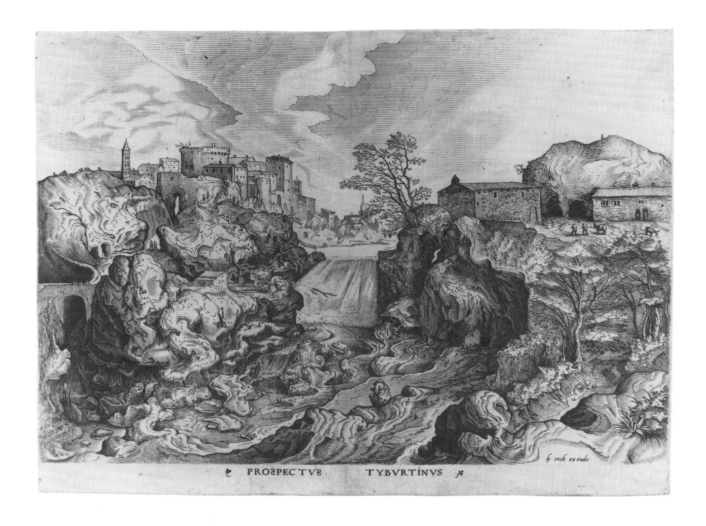

PROSPECTVS TYBVRTINVS

4 *View of the Tibur* **(Tivoli),** c. 1555-56

Etching and engraving by Jan and Lucas van Duetecum

Artists frequently pilgrimaged to Tivoli to draw the ruins of Roman villas, which lined the riverbanks. Instead of creating an image which romanticizes the vestiges of past civilizations, Bruegel focuses on a dramatic scene which gives the viewer a sense of geologic time. He depicts the raging river which over time had worn a path through the massive rock formations which comprise its banks.

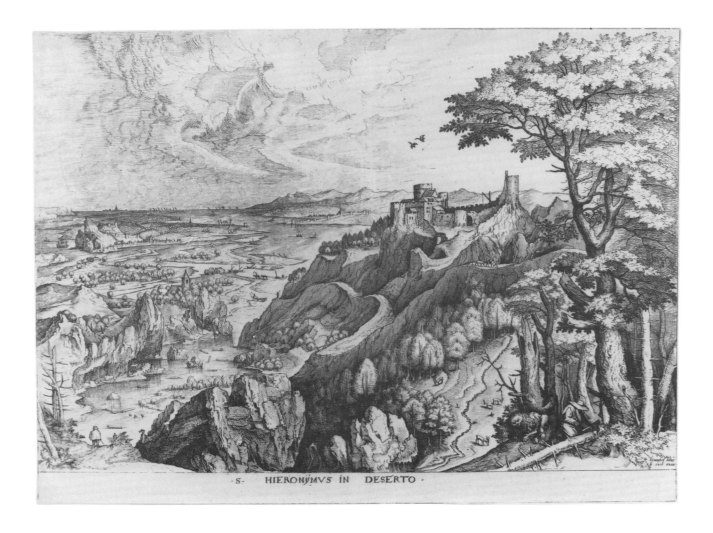

·S· HIERONYMVS IN DESERTO ·

5 *Saint Jerome in the Wilderness,* c. 1555-56

Etching and engraving by Jan and Lucas van Duetecum

Saint Jerome was highly esteemed as the first great Christian scholar, scorning his classical Ciceronian education to translate the scriptures into Latin. To concentrate on this task, Saint Jerome fled the decadent Roman empire and became a hermit, living in the desert southeast of Antioch. Here, the landscape designed by Bruegel is not a desert, but a world landscape that combines elements of Alpine topography with the Flemish plain. The figure of Saint Jerome was probably designed and added later by the publisher of the print, Hieronymus Cock. The title too may have been supplied by Cock, reinforcing the religious element of what otherwise could be seen as a landscape with incidental figures.

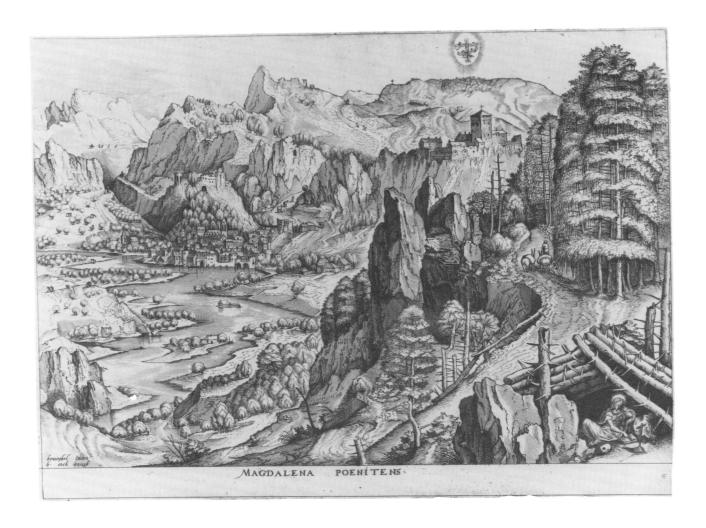

MAGDALENA POENITENS.

6 *The Penitent Magdalene,* c. 1555-56

Etching and engraving by Jan and Lucas van Duetecum

The figure of Mary Magdalene appears twice in this print. The jutting rocks and the delicately rendered yet massive trees lead the viewer from the figure reading at the lower right toward the small figure of the saint elevated by angels in the sky. This print may be composed from two Bruegel drawings of Alpine landscapes, neither of which includes human figures. The figures of Mary Magdalene may have been added by the publisher Hieronymus Cock to appeal to both an increasing interest in landscapes with mythological and biblical subjects, and a new humanist association of the divine and natural worlds.

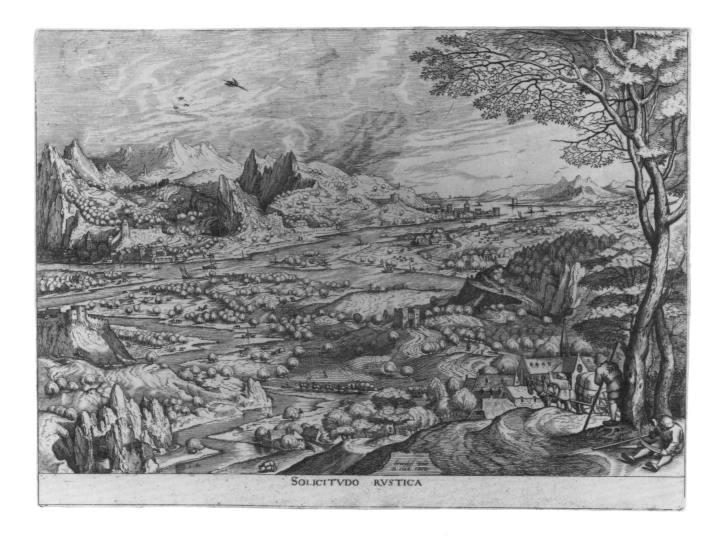

SOLICITVDO RVSTICA

7 *Rustic Solicitude,* c. 1555-56

Etching and engraving by Jan and Lucas van Duetecum

Rustic Solicitude, one of a series of twelve large Alpine landscapes, depicts two peasants on the nearest slope and one moving down a narrow path into the valley below. The landscape combines different viewpoints, including the immediate view from the cliff in the foreground and a distant view directed by the river, which bends sharply into the distance. Perhaps more than in any of the other large land-scapes, Bruegel and Cock have clearly defined a human and animal presence within the highly detailed topography. An image like *Rustic Solicitude*, depicting the awesome diversity of the natural world while making it more accessible to man, would have been appealing to the humanist population in Antwerp.

PAGVS NEMOROSVS

8 *Wooded Region,* c. 1555-56

Etching and engraving by Jan and Lucas van Duetecum

Wooded Region foreshadowed the transformation in Flemish art from monumental world landscapes encapsulating diverse aspects of the earth's topography to small-scale, intimate views of the rustic countryside. Despite forward looking elements such as its low viewpoint and topographical simplicity, this print still depicts foliage which is fantastically rich and lush. The publication of Bruegel's more intimate landscapes contributed to the evolution of forest views, popular in Flanders after 1600.

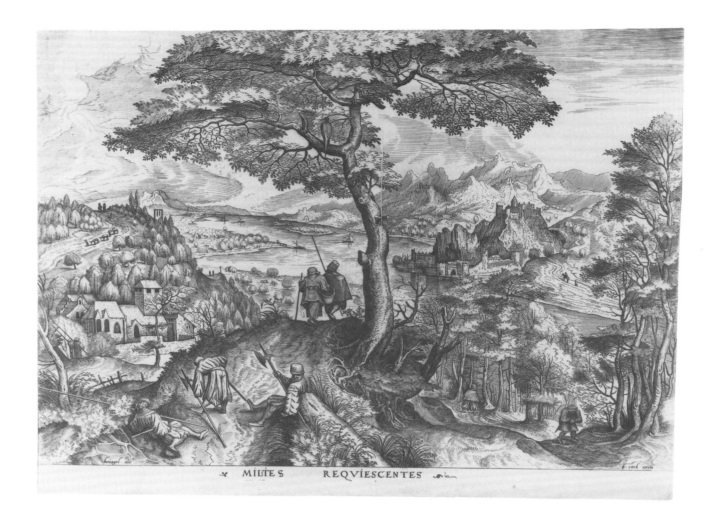

MILITES REQVIESCENTES

9 *Soldiers at Rest,* c. 1555-56

Etching and engraving by Jan and Lucas van Duetecum

Soldiers at Rest is a world landscape populated with peasants and soldiers in peaceful coexistence; however, it also has a more ominous tone. A gallows stands on a distant hill, and the faceless peasants and soldiers lurk mysteriously, perhaps aware of the unrest in the air. In tranquil contrast, several places of worship are represented, including a remote and rustic pilgrimage sight by the river's edge. Bruegel may have been referring to the religious climate of the 1550s, when Philip II of Spain issued placards against heresy, condemning those who were openly Protestant and creating a tense environment of persecution. However, by constructing a landscape which eludes exact identification, Bruegel avoids any overt political overtones.

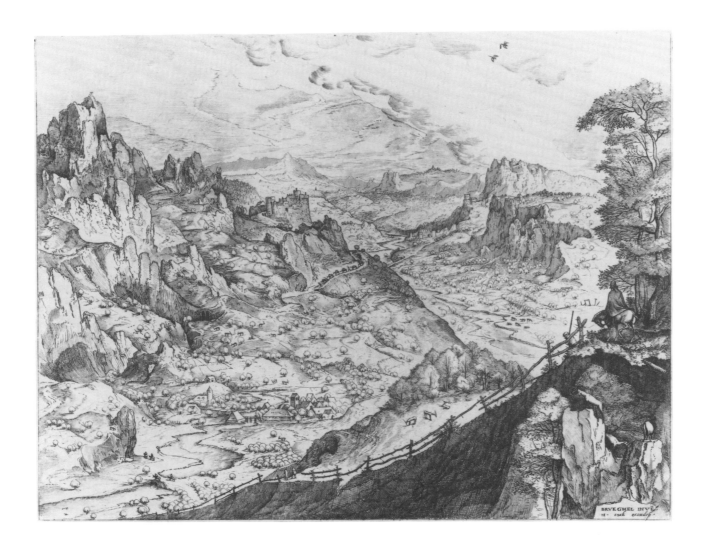

10 *Large Alpine Landscape,* c. 1555-56

Etching and engraving by Jan and Lucas van Duetecum

Large Alpine Landscape is topographically more dramatic than other Bruegel landscapes, and the largest
in scale. A cloaked figure on horseback gazes down from the precipitous cliff on the right, inviting the
viewer to look into the fertile valley below. Conrad Gesner, a Swiss natural historian and an early
climber of the Alps, wrote in 1555, "There is no lack of lookouts and crags on which you may seem to
yourself to be already living with your head in the clouds. If on the other hand you should prefer to
contract your vision, you will gaze on meadows and verdant forests, or even enter them; or to narrow it
still more, you will examine dim valleys, shadowy rocks, and darksome caverns." Bruegel's depiction of
the Alps may reflect an emerging reverence for the sublime nature of the mountain range.

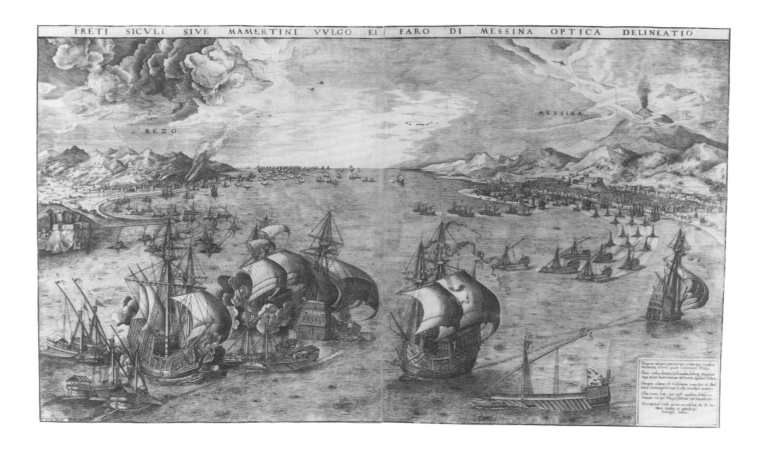

11 *Naval Battle in the Strait of Messina,* 1561

Based in part on drawings of c. 1552-53
Engraving by Frans Huys

A visual delineation of the Sicilian or Mamertine Strait commonly known as the Beacon of Messina. The famous port and city of Trinacria, ancient Messina which the Pelasgians of old constructed. On the right side you see both the cliffs and the homes of the Giants, where Aetna flashes ominously with nocturnal fires. Reggio, the crossing of Calabrians, is on the left: but that space, between each side of the strait, with Scylla, the terrible monster, once was land, which, after having been shaken, gaping open received the Ionian Sea, and an abyss was formed. (1561)

While in Italy in the summer of 1552, Bruegel may have witnessed the attacks of one hundred Turkish ships on Italian coastal towns. The burning city of Reggio, the location of one attack, is depicted in the upper left. However, this image is not an immediate documentary view, but an unusually large composition printed from two plates and compiled from many separate studies.

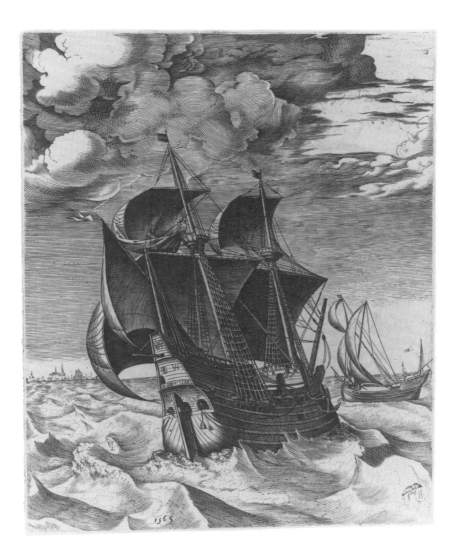

12 *A Dutch Hulk and a Boeier,* 1565

Engraving attributed to Frans Huys

This ship 1564.

Bruegel's prints of ships not only document their physical characteristics but possess the same emotional drama found in his landscapes. Here, the turbulent water, matched in mood by the dark and swarthy sky, emphasizes the ship's enormous task of struggling against the omnipotent sea. Bruegel's intended audience was most likely the merchant class of Antwerp, who were proud of the ships that transported goods from the city's harbor.

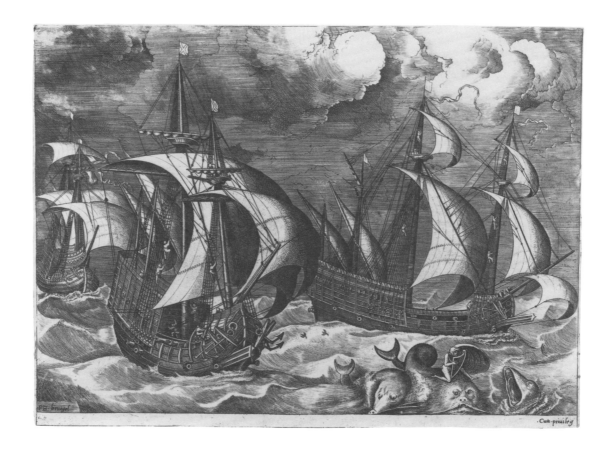

13 *Three Caravels in a Rising Squall with Arion on a Dolphin,* c. 1560-62

Engraving by Frans Huys

The Greek poet Arion, returning to Corinth from Sicily after having received many honors for his beautiful music, was robbed by his ship's crew. Before being thrown into the sea, Arion asked to play one more song on his lyre. His lyrical music attracted a group of dolphins, who are depicted in this print as fantastic creatures who save Arion from certain death in the stormy sea. Though the whimsical dolphins resemble Bruegel's bizarre animals in other drawings and prints, it is unclear whether the figure of Arion and the dolphins are of his own design or an addition by another hand.

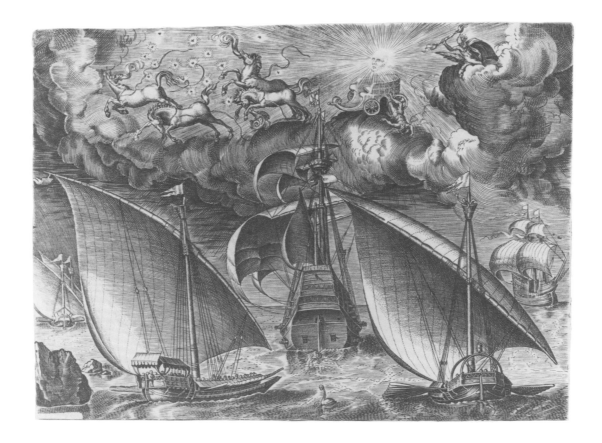

14 *Two Galleys Sailing behind an Armed Three-Master with Phaëthon and Jupiter in the Sky,* c. 1560-63

Engraving attributed to Frans Huys or Cornelis Cort

This print is a brilliant juxtaposition of fantasy and reality. A detailed study of contemporary ships contrasts in subject and tone with the dramatic display of Phaëthon's fall in the upper half of the image. The son of the nymph Clyemene and the sun-god Apollo, Phaëthon asks for the honor of driving Apollo's chariot across the skies. Phaëthon, part mortal, loses control of Apollo's horses, wreaking havoc on the earth below until his course is stopped by Jupiter's thunderbolt (the moment represented here by Bruegel). Apollo's remorse is reflected in the somber face of the sun, radiating beams of sunlight in the tumultuous sky.

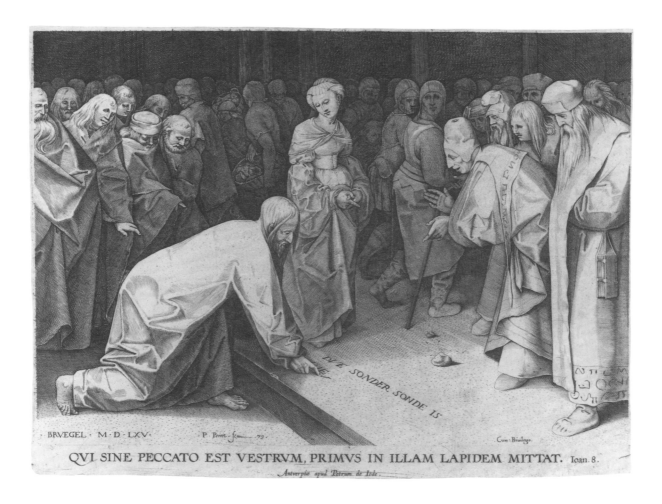

BRVEGEL · M · D · LXV · P · Perret · fecit · 79 · Cum · Privilegio ·

QVI SINE PECCATO EST VESTRVM, PRIMVS IN ILLAM LAPIDEM MITTAT. Ioan. 8.

Antverpiæ apud Petrum de Iode.

15 *Christ and the Woman Taken in Adultery,* 1579

After a grisaille painting of 1565
Engraving by Pieter Perret

He that is without sin among you, let him first cast a stone at her. John 8:7.

Christ and the Woman Taken in Adultery was executed after the death of Bruegel by the engraver Pieter Perret. Bruegel chose to represent a dramatic moment described in the Book of John in which the Pharisees challenge Christ to overrule the law of Moses, which advocated death by stoning for the adulterous. Instead Christ bends and writes in the earth before him, "He who is without sin, let him cast the first stone." The printmaker reveals the subject's emotional gravity through the use of dramatic light effects which illuminate the principle figures of the scene and push the secondary figures into a shadowy background.

16 *The Resurrection*

After a monochrome wash drawing of c. 1562
Engraving attributed to Philipp Galle

Bruegel combines elements from two biblical descriptions of Christ's resurrection (Mark 16:1-7 and Matt. 28:2-8) to create a narrative which includes both Christ's followers and the Roman soldiers responsible for guarding his tomb. Bruegel represents Mary Magdalene and her companions bearing spices to anoint the body of Jesus. They arrive at Christ's tomb to find it empty and surrounded by surprised Roman guards. Neither Mary Magdalene nor the guards notice Christ above them. The delicate tonal gradations of *The Resurrection* add to the subtle drama and show the engraver's close adherence to Bruegel's original design in grisaille.

17 *The Death of the Virgin,* 1574

After a grisaille painting of c. 1564
Engraving by Philipp Galle

Thus Philipp Galle copied the archetype by Pieter Bruegel. Abraham Ortelius and his friend attended to its making. Virgin, when you sought the secure realms of your son, what great joys filled your breast! What had been sweeter to you than to migrate from the prison of the earth to the lofty temples of the longed-for heavens! And when you left the holy band whose support you had been, what sadness sprang up in you; how sad and also how joyful was that pious group of yours and your son's as they watched you go. What pleased them more than for you to reign; what was so sad as to do without your face? This picture painted by an artful hand shows the happy bearing of sadness on the faces of the just.

The story of the Virgin's death is attributed to St. John the Evangelist, who may be depicted at the left of this image dreaming of the event that unfolds before the eyes of the viewer. Bruegel creates a humanistic depiction of the event, representing the twelve apostles praying by Mary's bedside among a group of simple and righteous mourners. The engraver was true to Bruegel's design in grisaille, capturing the unique lighting effects of the original.

MVLTÆ TRIBVLATIONES IVSTORVM, DE OMNIBVS IIS LIBERABIT EOS DOMINVS· PSAL· 33·

18 *The Temptation of Saint Anthony,* 1556

Engraving attributed to Pieter van der Heyden

Many are the afflictions of the righteous, but the Lord delivereth him out of them all. Psalm 34:19.

This print is the first in a series of figural compositions designed by Bruegel in the manner of Hieronymus Bosch, moralizing in content and grotesque in form. Saint Anthony was a religious hermit in the Egyptian desert, and experienced hallucinations as a result of his ascetic life in a harsh and remote environment. The Temptation of Saint Anthony was a popular subject in the circle of Bosch, and is the theme of his famous image of lust, the *Saint Anthony Triptych*. Here Bosch-like grotesques emphasize the fantastic world imagined by Saint Anthony and critique the corruption of the world. The one-eyed head and the rotting fish have been interpreted as symbols of the corruption of government and church.

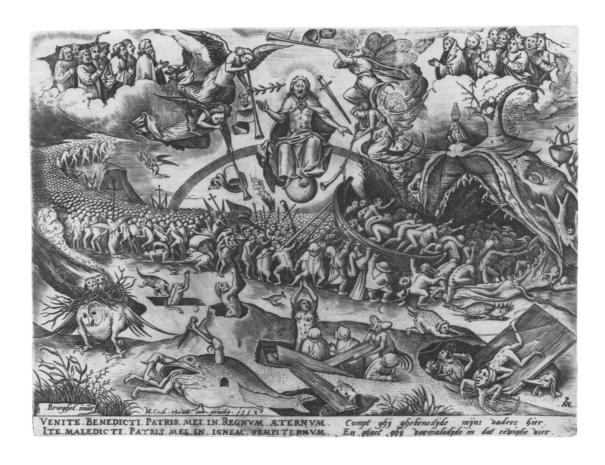

VENITE . BENEDICTI . PATRIS . MEI . IN . REGNVM . ÆTERNVM . Compt ghy ghebenedyde myns baders hier .
ITE . MALEDICTI . PATRIS . MEI . IN . IGNEM . SEMPITERNVM . En ghnet ghy vermaledyde in dat eewighe vier .

19 *The Last Judgment*, 1558

After a drawing of 1558
Engraving by Pieter van der Heyden

Come you, blessed by my father, to the eternal kingdom; and you, cursed by my father, go to everlasting fire.

The Last Judgment follows both chronologically and theologically *The Seven Deadly Sins* series (cat. 22-28). Many of the grotesque figures found in the *Sins* series, including the peacock that is the attribute of Pride, are included here to taunt the pleading damned as they are sent through the mouth of Leviathan into Hell. Christ, whose mercy and severity are symbolized respectively by the lily and sword beside him, addresses the blessed through his raised hand, while condemning the damned with a dismissive, yet placid gesture. Christ's peaceful judgment of both the blessed and the damned reflects Bruegel's understanding of him as a sympathetic judge of humankind.

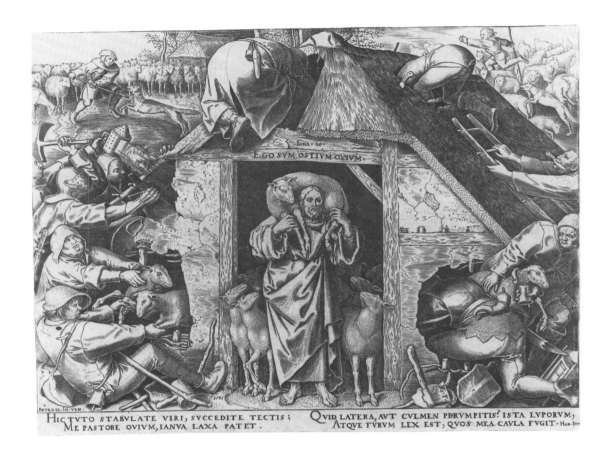

20 *The Parable of the Good Shepherd,* 1565

Engraving by Philipp Galle

I am the door of the sheep. John 10. Stable your flocks safely here, o men, come under my roof; while I am shepherd of the sheep the door is open. Why are you breaking into the walls or the roof? This is the way of wolves and thieves, whom my sheepfold shuns. Hadrianus Junius.

In *The Parable of the Good Shepherd* Bruegel depicts Christ at the center of the composition, carrying a ewe over his shoulders, protecting her and the gentle sheep that surround him from determined thieves. In the upper left of the composition, Bruegel shows the nature of the good shepherd, willing to die to protect his flock from wolves. At the upper right, the artist represents a faithless shepherd who runs from wolves that attack his sheep. Bruegel comments on the nature of Christ as one who died for his flock and on the need for the individual to maintain faith in the face of all obstacles. The inscription below the image is by Bruegel's contemporary, the doctor and humanist scholar Hadrianus Junius.

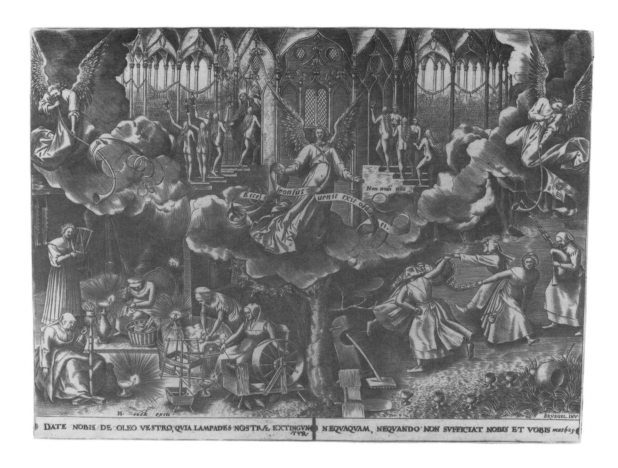

DATE NOBIS DE OLEO VESTRO, QVIA LAMPADES NOSTRÆ EXTINGVNTVR NEQVAQVAM, NEQVANDO NON SVFFICIAT NOBIS ET VOBIS *math 25*

21 *The Parable of the Wise and Foolish Virgins,* c. 1560-63

Engraving attributed to Philipp Galle

(And the foolish said unto the wise,) give us of your oil, for our lamps are gone out. (But the wise answered, saying,) not so, lest there be not enough for us and you. (Matt. 25:8-9) *Behold, the bridegroom cometh. Go ye out to meet him.* (Matt. 25:6) *I do not know you.* (Matt. 25:12)

The parable of the wise and foolish virgins is a veiled reference to Christ's Second Coming. It tells of ten maidens who accompany a bride to the house of her groom, symbolizing the house of Christ. The five wise maidens, who have spent their evenings working diligently by the light of their lamps, bring enough oil to keep the lamps lighted. The five foolish maidens, who have engaged in the idle behavior of dancing, must leave the house to retrieve oil for their lamps. When the foolish virgins return, they find the house of the groom (Christ) locked; the wise virgins are being greeted by the groom (Christ at the doors of heaven). Bruegel has constructed an intelligible order by dividing the composition into four quadrants.

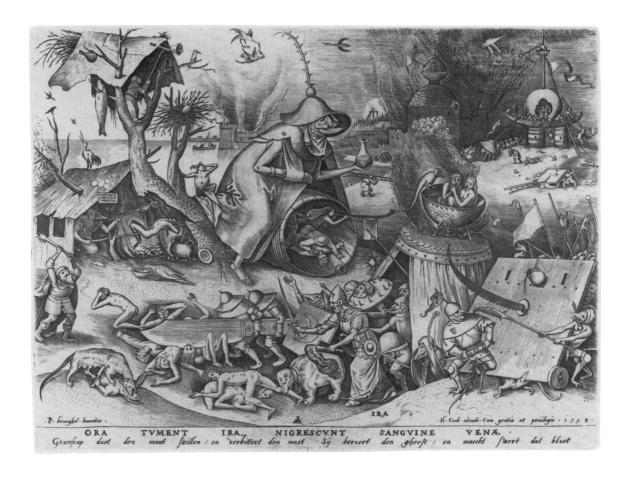

ORA TVMENT IRA,, NIGRESCVNT SANGVINE VENÆ.
Gramscap daet den mont swillen / en verbittert den moet Sy beroert den gheest / en maeckt swert dat bloet

22 *Anger*, 1558

After a drawing of 1557
Engraving by Pieter van der Heyden

Anger makes the face swell up and the veins grow black with blood. Anger swells the mouth, embitters the spirit and blackens the blood.

In the series *The Seven Deadly Sins*, Bruegel's Anger is engaged in unusually active behavior as compared to his other personifications of Sin. Perhaps this suggests the volatility and impulsiveness of the emotion. The world in which Anger dwells is ruthless, filled with monstrous acts of violence. The giant riding on a barrel and holding a carafe may refer to drunkenness; and the two men fighting in the barrel apparently represent drunkenness as a cause of anger.

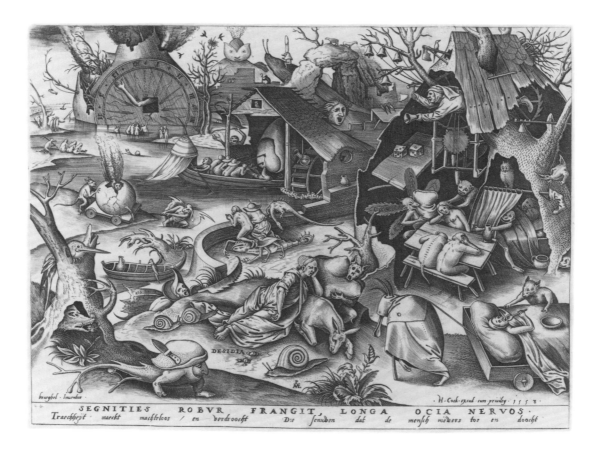

SEGNITIES ROBVR FRANGIT, LONGA OCIA NERVOS.
Traecheyt maeckt machteloos / en verdrooeft Die fenuwen dat de menfch niewers toe en dooeht

23 *Sloth,* 1558

After a drawing of 1557
Engraving by Pieter van der Heyden

Sluggishness breaks strength; long idleness ruins vigor. Sloth takes away all strength and dries out the nerves until man is good for nothing.

In *Sloth*, Bruegel again shows that a single vice is not self-contained, but leads to other mortal sins. As Sloth sleeps on her symbolic counterpart, the indolent ass, the results of her sin can be viewed in the surrounding scenes. In the hollow tree to her left, avaricious gamblers and a lustful pair in bed waste their days engaged in immoral and unproductive pursuits. As the inscription indicates, Sloth incapacitates the individual, making him incapable of morally sound activity.

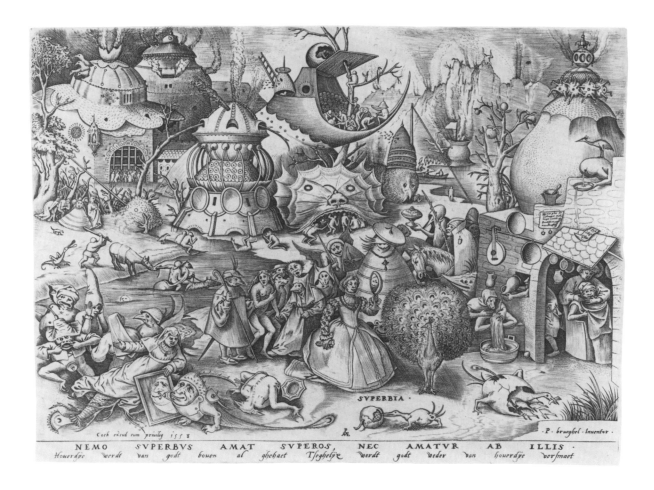

24 *Pride,* 1558

After a drawing of 1557
Engraving by Pieter van der Heyden

Nobody who is proud loves the gods above, nor is he loved by them. Pride is hated by God above all; at the same time, Pride scorns God.

Bruegel appropriates the fashion of the 1550s in his critique of Pride. The woman who looks into the mirror is admiring her ostentatious attire, which resembles the gaudy plumage of the vain peacock beside her. The demon in the foreground, dressed in ludicrous armor with a long peacock's tail, also gazes lovingly at his reflection. The monster to his right has been pierced through the back and lies dead, his backside still facing a mirror. The behavior of the demons reveals Pride as both a ridiculous and deadly sin.

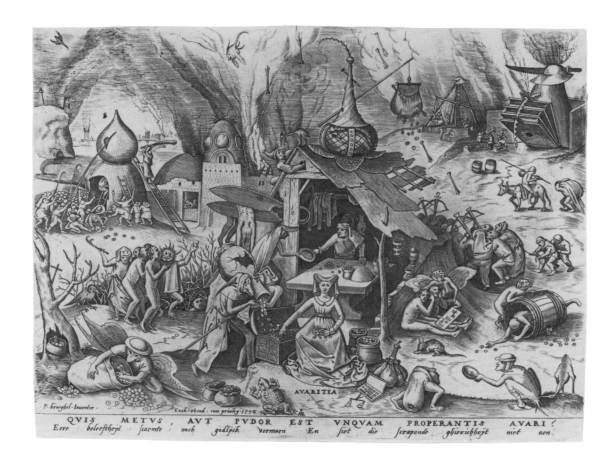

25 *Avarice*, 1558

After a drawing of 1556
Engraving by Pieter van der Heyden

Does the greedy miser ever possess fear or shame? Grasping Avarice sees neither honor, courtesy, shame, nor divine command.

The drawing for *Avarice* was made the year before Bruegel executed the drawings for the six remaining *Deadly Sins*. It has been argued that it was the first print in the series to be designed, because Avarice is the source of all other sins. Avarice sits amidst her moneybags and chests, wearing an outmoded gown and headdress which emphasize her foolishness and stinginess.

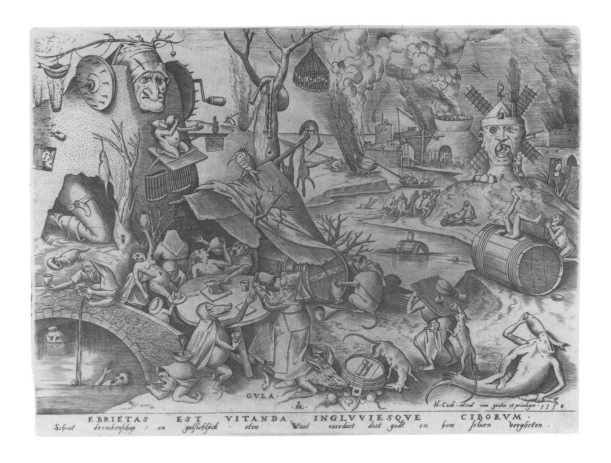

GVLA.

EBRIETAS EST VITANDA, INGLVVIESQVE CIBORVM.
Schout dronkenschap / en gulsichsick . eten Want ouerdaet doet godt en hem seluen verghoten .

26 *Gluttony*, 1558

After a drawing of 1557
Engraving by Pieter van der Heyden

Drunkenness and gluttony are to be shunned. Shun drunkenness and gluttony, for excess makes a man forget both God and himself.

Though modern viewers may associate gluttony with mere overeating, Bruegel's *Gluttony* includes both the drunk and the overfed. Characteristic of Bruegel's *The Seven Deadly Sins* series, humans intermingle with anthropomorphic demons, reduced to a similar level of baseness through vice. Blatant examples of Gluttony abound. The fish monster in the lower right continues to feed himself despite his split belly, while an obese man carries his large gut in a wheelbarrow as he lumbers toward a river. Dame Gluttony, dressed as a Flemish burgher's wife, is being encouraged to imbibe by a demon clothed in monk's garb, suggesting that Gluttony knows no social or economic boundaries.

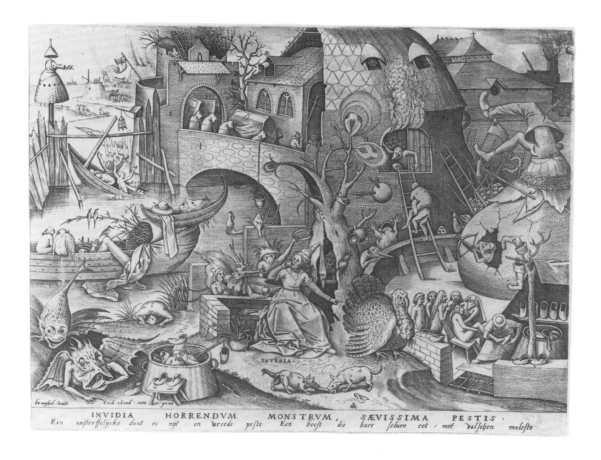

INVIDIA HORRENDVM MONSTRVM, SÆVISSIMA PESTIS ·
Een onfterffelijcke doot es nijt / en wreede peſte Een beeſt die haer felven eet / met valſchen moleſte

27 *Envy,* 1558

After a drawing of 1557
Engraving by Pieter van der Heyden

Envy is a monster to be feared and a most savage plague. Envy is an eternal death and a terrible sickness, a monster which devours itself in imaginary sorrow.

Bruegel reminds the viewer of the close relationship between Envy and Pride in this absurd netherworld of demons and humans. Envy, literally eating her heart with spite, sits in front of a tree decorated with peacock feathers, a symbol of pride. According to the Netherlandish humanist Dirck Volkertszoon Coornhert's hierarchy of sins, Envy is "the eldest daughter of Pride," when excessive self-love causes ill will toward another.

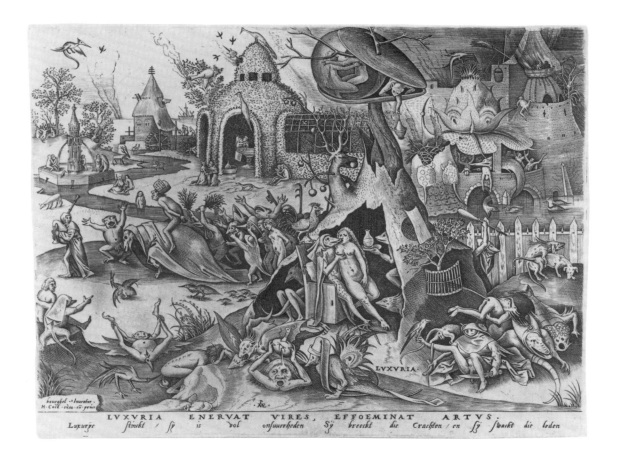

LVXVRIA ENERVAT VIRES, EFFOEMINAT ARTVS.
Luxurye stinckt / sy is vol onsuuerheden Sy breeckt die Crachten / en sy swackt die leden

28 *Lust*, 1558

After a drawing of 1557
Engraving by Pieter van der Heyden

Lust enervates the strength, weakens the limbs. Lechery stinks, it is dirty. It breaks the strength and weakens limbs.

In *Lust*, Bruegel employs a hollow tree which derives from Hieronymus Bosch's "love pavilion" in *The Tabletop of the Seven Deadly Sins* (in the Prado, Madrid). As in *Gluttony*, no social class is free from Bruegel's criticism. The naked figure riding a skeleton monster in the center left is an adulterer drawn from Bosch's *The Garden of Earthly Delights*. In Bruegel's original drawing (in the Bibliothèque Royale, Brussels), this figure wears a Bishop's miter. In an environment in which criticism of the Church could be dangerous, this detail was changed into an ordinary hat in the final print.

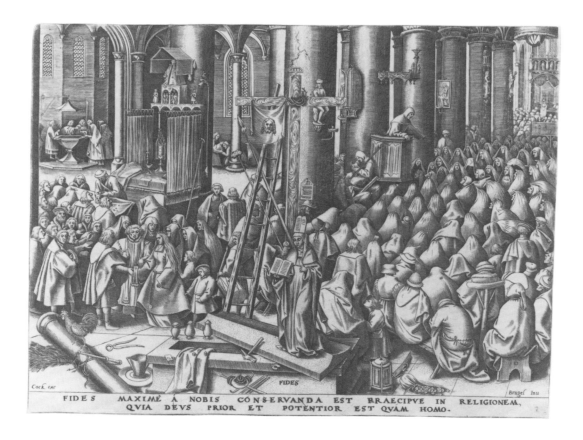

FIDES MAXIMÉ À NOBIS CÓNSERVANDA EST BRAECIPVE IN RELIGIONEM,
QVIA DEVS PRIOR ET POTÉNTIOR EST QVAM HOMO.

29 *Faith,* 1559-60

After a drawing of 1559
Engraving attributed to Philipp Galle

Above all we must keep faith, particularly with respect to religion, for God comes before, and is mightier than man.

Faith, the first of the theological virtues, is also the first print in the series *The Seven Virtues*. Bruegel shows his familiarity with medieval manuscripts in his design for *Faith*, representing her within a church instead of in the traditional manner with a church on her head. It has been argued that Bruegel is acknowledging the debate between the Catholic and Protestant faiths, since he emphasizes both the Eucharistic celebration, a subject of that debate, and a sermon from a pulpit, an important part of a sixteenth-century Protestant service.

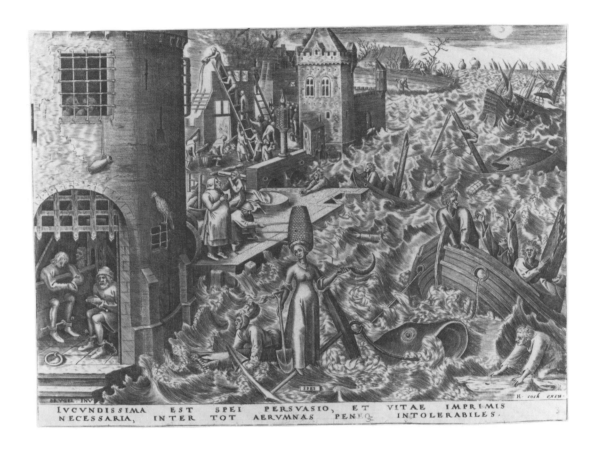

IVCVNDISSIMA EST SPEI PERSVASIO, ET VITAE IMPRIMIS
NECESSARIA, INTER TOT AERVMNAS PENEQ INTOLERABILES.

30 *Hope,* 1559-60

After a drawing of 1559
Engraving attributed to Philipp Galle

Very pleasant is a conviction of hope and most necessary for life. (Hope is essential) amid many and almost unbearable hardships.

Amidst shipwrecks, fire, and famine, Bruegel's allegorical figure of Hope stands solemnly on an anchor. She holds a spade and scythe, which symbolize the risk-laden professions of sailor and farmer, respectively. The beehive on her head symbolizes the hope for general prosperity and well-being. The bee represents Faith in Christian iconography, returning daily to the hive after hours of arduous and selfless work. Thus Bruegel indicates that Faith is the root of all virtue, including Hope. The figures in Bruegel's engraving clasp their hands in prayer or raise them to an invisible God, suggesting that it is Faith which provides them with the hope for salvation despite seemingly insurmountable odds.

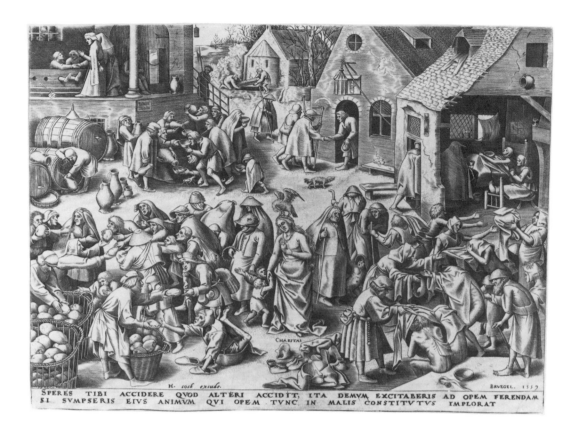

31 *Charity,* 1559

After a drawing of 1559
Engraving attributed to Philipp Galle

Expect what happens to others to happen to you; you will then and only then be aroused to offer help when you make your own the feelings of the man who appeals for help in the midst of adversity.

The Netherlandish humanist Dirck Volkertszoon Coornhert believed that true virtue must go beyond theory and be exemplified by practical action. Bruegel, part of the same intellectual circle as Coornhert, represents Charity in both theoretical and practical terms. The allegorical personification of Charity holds in her hand a flaming heart, which symbolizes the love of God. A pelican, thought to give its own blood to feed its young, perches on her head. The children at her side symbolize the generosity of a good mother. Charity is surrounded by the Seven Acts of Mercy: tending to the hungry, the thirsty, the stranger, the naked, the sick, and the prisoner, and burying the dead.

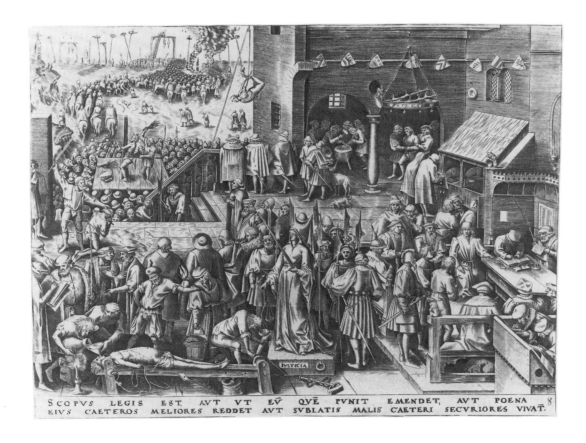

SCOPVS LEGIS EST, AVT VT EV QVE PVNIT EMENDET, AVT POENA
EIVS CAETEROS MELIORES REDDET AVT SVBLATIS MALIS CAETERI SECVRIORES VIVAT.

32 *Justice,* 1559-60

After a drawing of 1559
Engraving attributed to Philipp Galle

The aim of law is either to correct (through punishment) him who is punished, or to improve the others by his example, or to provide that the population (others) live more securely by removing wrongdoers.

From *Justice*, the viewer can obtain a better understanding of the punishments accepted by Bruegel's society as methods of maintaining social order. The torture scene in the lower left corner is particularly graphic. The hapless prisoner is being burned with fiery pitch, stretched on a rack, and forced to drink water poured through a funnel, further engorging his already swollen belly. Though Bruegel may not have approved of such harsh punishment, he does not overtly criticize this type of justice.

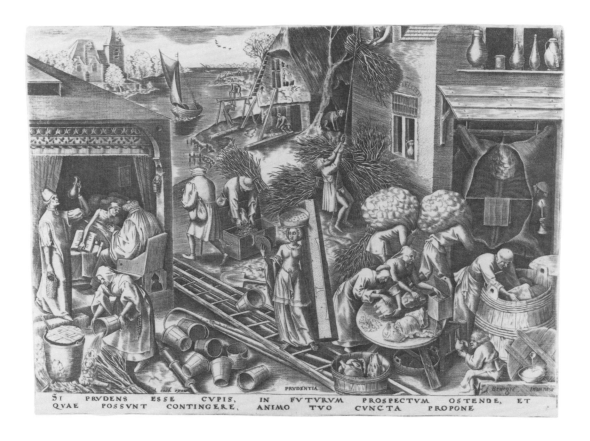

SI PRVDENS ESSE CVPIS, IN FVTVRVM PROSPECTVM OSTENDE, ET QVAE POSSVNT CONTINGERE, ANIMO TVO CVNCTA PROPONE

33 *Prudence,* 1559-60

After a drawing of 1559
Engraving attributed to Philipp Galle

If you wish to be prudent, think always of the future and keep everything that can happen in the forefront of your mind.

Unlike the mirror held by Pride in Bruegel's series *The Seven Deadly Sins,* which is meant to reveal her smug reflection to the world, the mirror held by Prudence is used for self-reflection. The moral writer Cesare Ripa, who was influential in the intellectual circle of Bruegel, wrote: "Looking into a mirror represents learning to know one's self, for no one who is unaware of his own failings can judge soundly regarding his affairs."

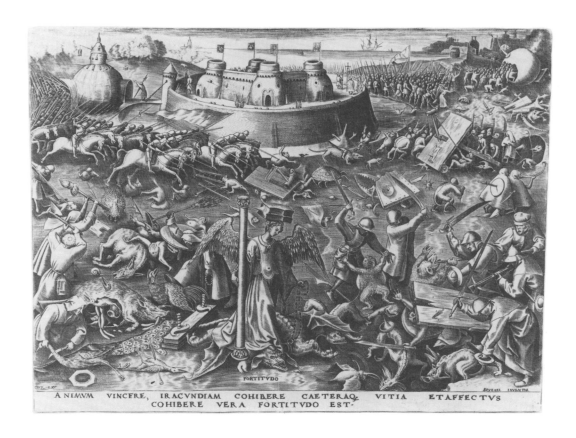

ANIMVM VINCERE, IRACVNDIAM COHIBERE CAETERAQ VITIA ETAFFECTVS COHIBERE VERA FORTITVDO EST·

34 *Fortitude,* 1560

After a drawing of 1560
Engraving attributed to Philipp Galle

To conquer one's impulses, to restrain anger and the other vices and emotions: this is true fortitude.

In this engraving from *The Seven Virtues* series, the monsters of Bruegel's *The Seven Deadly Sins* reappear. But instead of roaming unchecked, they are held back by the soldiers of Fortitude. The inscription indicates that this battle represents the struggle of the individual to subdue inclinations toward vice, a fight which is won by those with superior fortitude. Bruegel's design effectively utilizes space to include dozens of surging soldiers at the right and left, and thus anticipates his later biblical paintings, *The Suicide of Saul* and *The Conversion of St. Paul on the Road to Damascus* (both in the Kunsthistorisches Museum, Vienna).

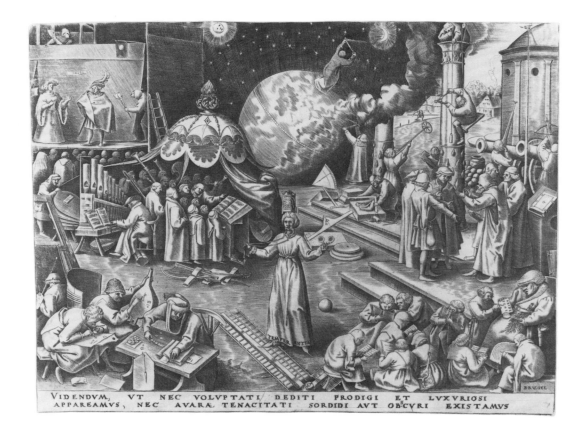

VIDENDVM, VT NEC VOLVPTATI DEDITI PRODIGI ET LVXVRIOSI APPAREAMVS, NEC AVARÆ TENACITATI SORDIDI AVT OBSCVRI EXISTAMVS

35 *Temperance,* 1560

After a drawing of 1560
Engraving attributed to Philipp Galle

We must look to it that, in the devotion to sensual pleasures, we do not become wasteful and luxuriant, but also that we do not, because of miserly greed, live in filth and ignorance.

Surrounding the allegorical personification of Temperance, who carries the bit of self-restraint in her mouth, are the Seven Liberal Arts: Grammar, Logic, Rhetoric, Geometry, Arithmetic, Astronomy, and Music. Bruegel may have been suggesting that Temperance is the antidote to Sloth, allowing the individual to engage in the useful and productive activity embodied by the Seven Liberal Arts. He may also have intended to argue against the traditional definition of the Seven Liberal Arts by including a painter at the lower left of the print. Painting was not traditionally accepted as one of the Seven Liberal Arts.

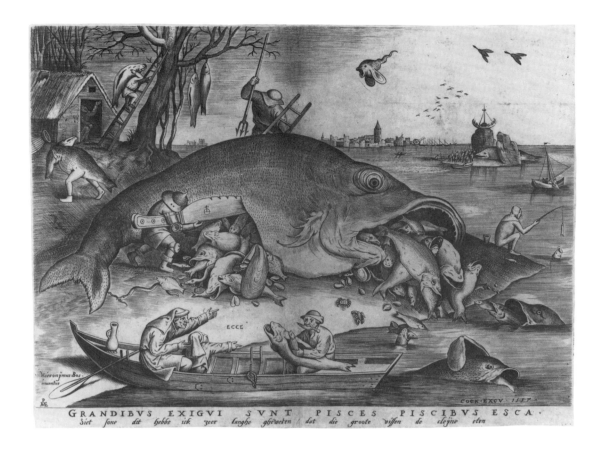

36 *The Big Fish Eat the Little Fish,* 1557

After a drawing of 1556
Engraving by Pieter van der Heyden

Little fish are the food of big fish. See, son, I have known for a long time that the big fish eat the small.

This engraving is based on a Bruegel drawing but is signed "Hieronymus Bosch, inventor." The signature is perhaps an attempt by the publisher to bolster print sales since Bosch's commercial appeal superseded Bruegel's in 1556, the date of the design. Bruegel's witty commentary on vice and his use of humanoid demons certainly reflect Bosch's influence. However, his theme is relevant to his own time, which was fraught with religious upheaval and the competitions of a growing market economy. It has been argued that the Flemish proverb "Big fish eat little fish" may refer not only to the dynamics of the food chain, but also to the dominance of the economic and political elite in the Netherlands during the sixteenth-century. The fishlike figure in the upper left, running off on his two human legs with a smaller fish between his jaws is an allusion to the aggressive behavior of man. The distant port on the horizon line is a reminder of Netherlandish prosperity.

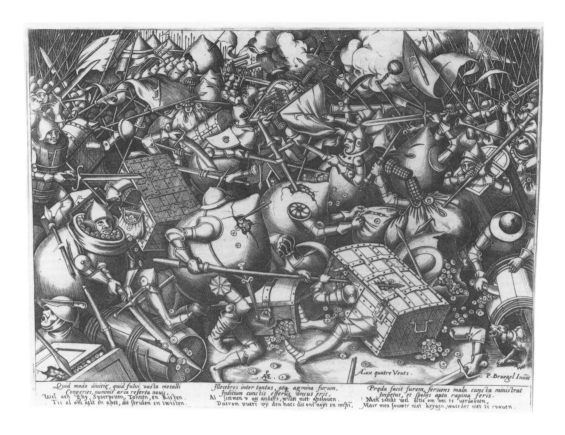

37 *The Battle of the Moneybags and the Strongboxes,* after 1570

Engraving by Pieter van der Heyden

The savage hook will reveal to all the riches, the vast pile of yellow metal, the strong box stuffed with new coins among these great enticements and the ranks of thieves. Booty makes the thief, the assault that serves all evil helps him, and so does the pillage good for fierce spoils. Come on, you money boxes, barrels, and chests, it's all for money and goods, this fighting and quarreling. Even if they say it's different, don't believe it. That is the reason we carry the hook on our banners which has never failed us. They are taking action to drug us. But one would not get anything if there were nothing to steal.

The Battle of the Moneybags and the Strongboxes was published after Bruegel's death by the widow of Hieronymus Cock. Bruegel's design for the engraving no longer exists, though similar commentaries on Avarice are certainly found in his oeuvre. Pottery banks, barrels, and money chests duel until their "deaths" in Bruegel's biting satire on greed and its violent results. Though the print has been interpreted as a critical commentary on the rich and their avaricious propensity for war, the inscription places a more general and less contentious blame on money as the impetus for all human conflict.

Die dâr luy en lacker sijt bôr crijsman oft clercken
die gheraeckt daer en smaeckt elck van als, sonder werken

Die tuynen sijn worsten die huysen met vlayen
cappuynen en kieckens tvluchter al ghebruyen

P. Breugel
inuentor.

38 *The Land of Cockaigne*

Based on a painting of 1567
Engraving attributed to Pieter van der Heyden

The lazy and gluttonous farmers, soldiers, and clerks get and taste all without working. The gardens
are sausages, the houses are made of tarts. The fowl fly by already roasted.

In the land of Cockaigne, the scholar, soldier, and farmer eat and drink all they desire without effort.
Fowl, pigs, and game willingly present themselves to be devoured. Bruegel's design depicts an oasis for
the spiritually empty, symbolized by the hollow egg scurrying across the foreground. The inscription
describes the three engorged and inert men represented by Bruegel as "lazy and gluttonous."

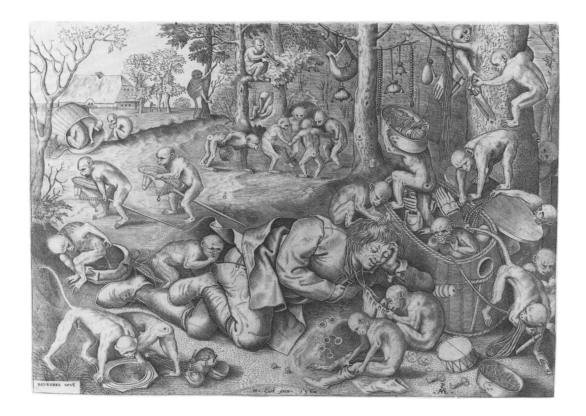

39 *The Merchant Robbed by Monkeys,* 1562

Engraving by Pieter van der Heyden

The plight of the sleeping peddler robbed by monkeys was a popular northern Renaissance subject, represented frequently in both the painting and print medium. The theme had already been used in marginal illuminations of the late Gothic period. Bruegel used the ape to humorously comment on human folly, particularly the results of sloth personified by the sleeping merchant.

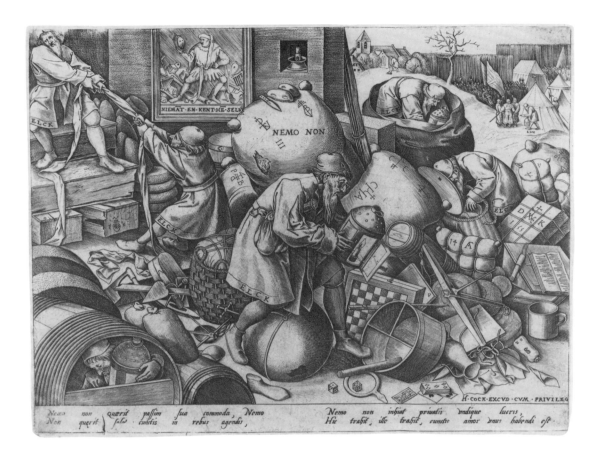

40 *Everyman*, c. 1558

After a drawing of 1558
Engraving attributed to Pieter van der Heyden

(There is) no one (who) does not seek his own advantage everywhere, no one (who) does not seek himself in all that he does, no one (who) does not look everywhere for private gain. This one pulls, that one pulls, all have the same love of possession.

In *Everyman*, human folly is seen in the search for material gain instead of the pursuit of self-knowledge. The spectacles worn by the central figure of Everyman and the lantern he carries in broad daylight will not aid him in his search, as long as he seeks money instead of wisdom. The picture on the wall behind him depicts a fool amidst a pile of clutter and bears the inscription, "Nobody knows himself." It suggests a spiritual blindness on the part of all men within a materialistic society.

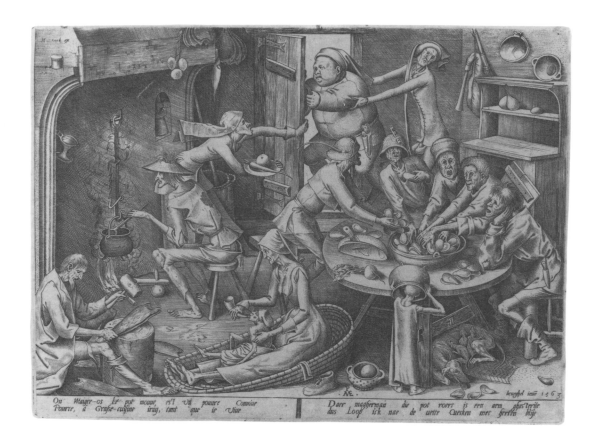

41 *The Thin Kitchen*, 1563

Engraving by Pieter van der Heyden

Where the thin man stirs the pot, meager fare is offered. Thus I'll gladly take myself off to the fat kitchen.

Like *The Fat Kitchen* (cat. 42), *The Thin Kitchen* was a very popular image. Four copies and two pastiches of the set were made. In *The Thin Kitchen*, Bruegel is critical of the rich and sympathetic toward the poor. The fat visitor seems uncomfortable and eager to flee the kitchen, while the skeletal poor offer their meager fare of bread, mussels, and turnips to the surprise "guest." Bruegel's contemporaries may have viewed this image as a tragicomical work.

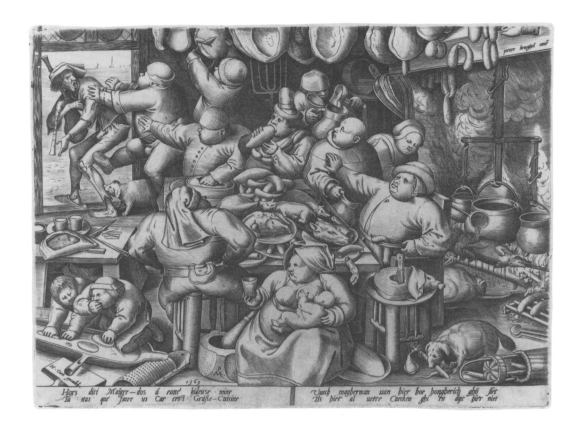

42 *The Fat Kitchen*, 1563

Engraving by Pieter van der Heyden

Go away thin man, no matter how hungry you are. This is the fat kitchen and you won't be served.

Bruegel appears to be aware of Hieronymus Bosch's use of the fat kitchen as a theme to illustrate the vice of gluttony. However, he takes this theme a step further by using it to illustrate the avaricious nature of the individuals depicted. The corpulent and distorted family, whose meal has been interrupted, displays outrage and embarrassment when the thin beggar tries to enter the overstocked kitchen. As a result, the unwillingness of the rich to address the needs of the poor is revealed.

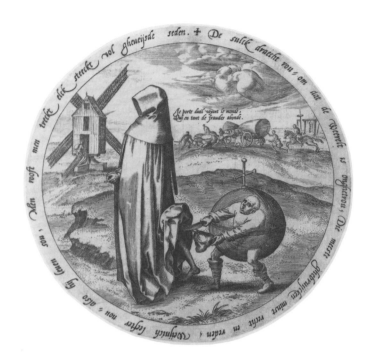

43 *The Misanthrope Robbed by the World,* perhaps c. 1568

Based on a painting of 1568
Engraving by Jan Wierix

I wear mourning seeing the world in which so many deceits abound. He wears mourning because the world is unfaithful; most people behave without rhyme or reason. Few now live as one should live. People rob,grab, and everyone is full of deceit.

The theme of the Misanthrope comes from a cynical proverb which advocates bowing to corruption as a form of self-protection. The Misanthrope represents those who stubbornly believe the world to be a moral place. The posture of the Misanthrope is stiff and straight; his hands are clasped in a gesture of faith, and he walks blindly amidst the moral chaos surrounding him. He is unaware of being robbed by a small figure in a globe, who represents the immorality of the world. To further emphasize the world's cruelty, the engraver includes a gallows and a wagon attacked by bandits. These details are absent from Bruegel's painting of the same title in the Gallerie Nazionali di Capodimonte, Naples.

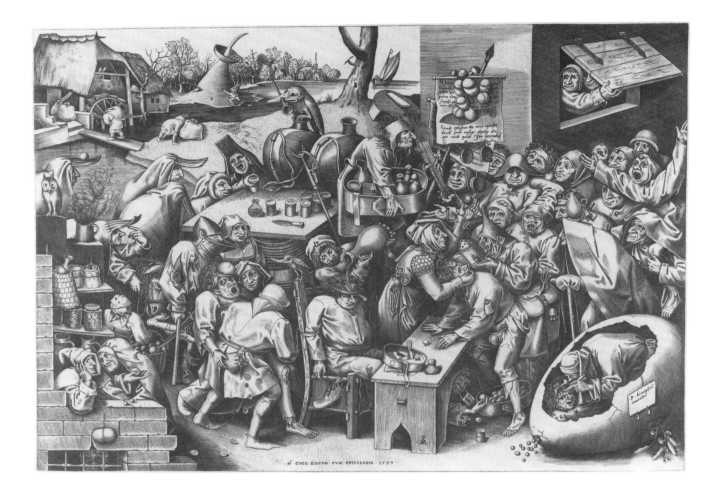

44 *The Witch of Mallegem,* 1559

Engraving by Pieter van der Heyden

The Witch of Mallegem represents the overzealous inhabitants of "Foolsville," crowding around a witch who travels between villages removing stones of foolishness from the heads of the gullible. These operations were frequently performed by charlatans at village festivals, generating income for the quack physician and providing comic entertainment for the audience. Bruegel mocks the peasants who believe in this cure, using ludicrous physiognomy and facial expressions to emphasize the foolishness of their behavior.

45 *The Festival of Fools*, after 1570

Probably after a drawing of c. 1568
Engraving by Pieter van der Heyden

You Dumbheads, who with frivolity are plagued, come to the lanes, whoever desires to bowl. Although one will lose his honor and the other his money, the world praises the greatest fools. One finds Dumbheads among every people, even if they do not wear a fool's cap on their heads. They have such grace in dancing, that their Fool's ball turns, just like a top. The dirtiest Dumbheads, squander their estates. Then there are those who tweak each other by the nose. Some such sell trumpets and others eyeglasses. There are many Dumbheads together over-valuing (these). There are even Dumbheads, who carry themselves wisely, and understand the proper meaning from the Dumbheads, because they (who) have found folly pleasing in themselves shall (with) their Fool's ball best of all touch the pin.

The inscription below *The Festival of Fools* makes an obvious reference to Desiderius Erasmus' *The Praise of Folly,* implying that fools may be wise if they recognize their own foolishness. However, Bruegel's figures engage in much more than mere foolish behavior. Many are using their foolishness as a clever disguise for deceit. The figure in the lower left selling eyeglasses is explained by the inscription, "Some [fools] sell trumpets and others eyeglasses. There are many Dumbheads together overvaluing (these)."

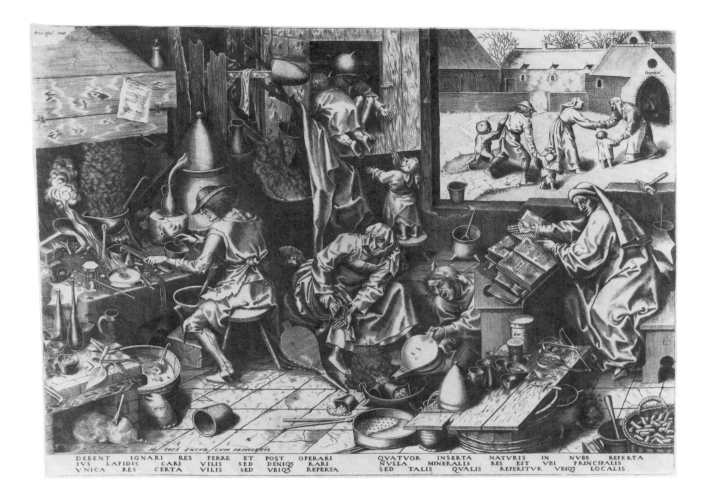

46 *The Alchemist,* probably 1558

After a drawing of 1558
Engraving attributed to Philipp Galle

The ignorant should suffer things and labor accordingly. The law of the precious, cheap but at the same time rare stone is the only certain, worthless but everywhere discovered thing. With four natures stuffed into the cloud it is no mineral that is unique somewhere but is of such a kind as to be found everywhere.

The Alchemist is one of the most famous prints after a Bruegel design. It is even mentioned in the writings of the Italian painter and art historian Giorgio Vasari. An alchemist combines diverse metals with the hope of transforming them into gold. Bruegel mocks alchemy as a pursuit of the greedy and foolish, reflecting a prominent attitude toward the profession. While the alchemist works relentlessly over a flame, his wife tries in vain to find money, and his children dig into an empty pantry. Through the window, we see the future of the alchemist, driven to a poorhouse as a result of his self-deception.

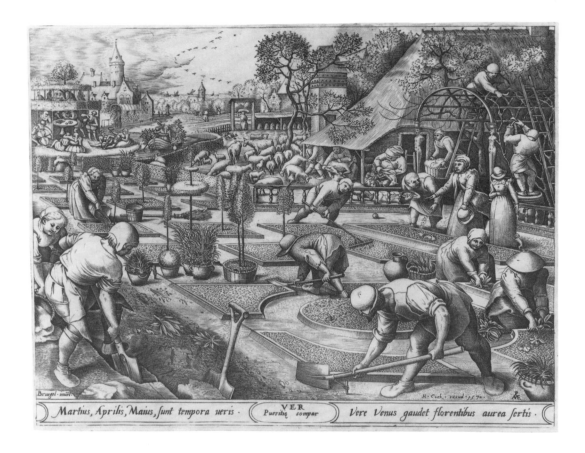

Martius, Aprilis, Maius, sunt tempora ueris · VER Pueritiæ compar · Vere Venus gaudet florentibus aurea sertis ·

47 *Spring,* 1570

After a drawing of 1565
Engraving by Pieter van der Heyden

March, April, and May are the months of Spring. Spring, similar to childhood. In Spring, golden Venus rejoices in garlands of blooming flowers.

Spring shows Bruegel's familiarity with the symbolism found in medieval manuscripts, which often used the labors of peasants to describe the seasons. *Spring* shows the difference in the seasonal activities of the peasantry and wealthy. Peasants tending a structured garden in the French style are overseen by a wealthy woman who casually dangles her fashionable hat. A group of well-dressed individuals eat, drink, and frolic; their courtly pursuit of love is associated with springtime. The inscription, probably added by Cock, compares springtime with the childhood of man.

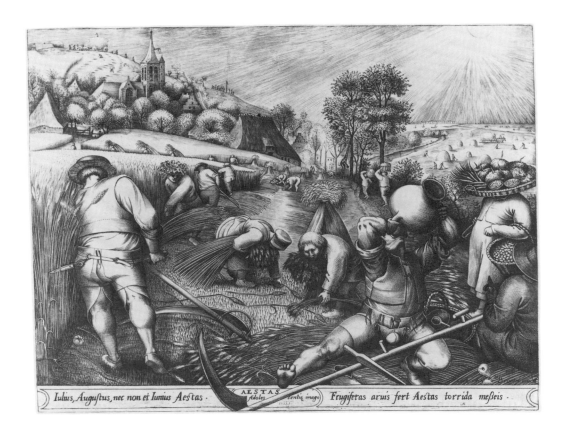

Iulius, Augustus, nec non et Iunius Aestas · | AESTAS Adolescentis imago | Frugiferas aruis fert Aestas torrida meßeis ·

48 *Summer*, 1570

After a drawing of 1568
Engraving by Pieter van der Heyden

July, August, and also June make Summer. Summer, image of youth. Hot summer brings bounteous harvests to the fields.

In *Summer*, Bruegel uses the labors of peasants to show the change of season. He consolidates the three summer months into a single image, but features the month of August, which is associated with the wheat harvest. The man in the right foreground is traditionally emblematic of summer. He drinks from a vessel, quenching his thirst as he rests from his labor in the sun. Bruegel's design for *Summer* reflects his interest in antique sculpture. The male figures, particularly the man in the foreground with dramatically foreshortened limbs, are among the most powerful in Bruegel's oeuvre, lending an uncommon dignity to this peasant subject.

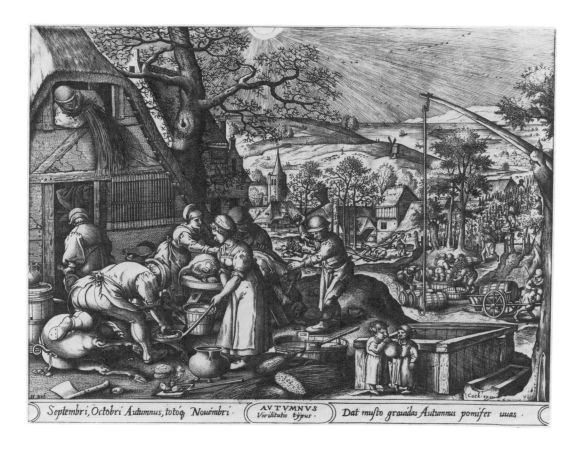

Septembri, Octobri Autumnus, totoq̃ Nouémbri · (AVTVMNVS Virilitatis typus ·) Dat musto grauidas Autumnus pomifer uuas ·

49 *Autumn,* 1570

Engraving by Pieter van der Heyden after a drawing by Hans Bol

Autumn with September, October, and, in all, November. Autumn the image of full-grown vigor. Fruit-bearing Autumn gives abundant grapes to the must (unfermented wine).

Autumn, an engraving by Pieter van der Heyden after Hans Bol, depicts peasants engaged in vigorous preparation for the winter. The only individuals indulging in idle behavior are the two small children in the foreground, who are blowing up a balloon made from a slaughtered animal's bladder. Many of the individuals depicted, particularly the figures gathering and stomping grapes in the background, are engaged in activities which typically symbolized autumn to Renaissance viewers. A remarkable sky has been created to accentuate the feeling of autumn, with the midday sun emitting a bright light over the cool landscape.

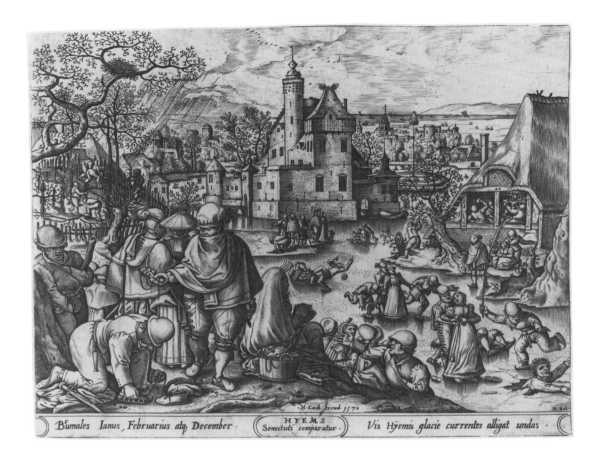

Bumales Ianus, Februarius atq; December · HYEMS Senectuti comparatur · Vis Hyemis glacie currentes alligat undas ·

50 *Winter,* 1570

Engraving by Pieter van der Heyden after a drawing by Hans Bol

Of short days are January, February, and December. Winter is like old age. The might of Winter binds with ice and flowing waters.

Winter, an engraving by Pieter van der Heyden after Hans Bol, imitates the monumental, muscular bodies found in Bruegel's *Spring* and *Summer*. Bol is also aware of Bruegel's skating scenes, such as *Skating before the Saint George's Gate, Antwerp* (cat. 52), and his representations of winter in works like the oil painting *Hunters in the Snow,* 1565 (in the Kunsthistorisches Museum, Vienna). In fact, Bol has reversed the emphasis of Bruegel's painting, placing peasants at leisure in the foreground space and those engaged in physical labor in secondary positions in the left background. Bol's image contains an implicit recognition of the consequences for peasants who choose leisure over winter labor. Their future plight is symbolized by the peasants standing precariously on the ice, slipping, or breaking through into the cold, treacherous water.

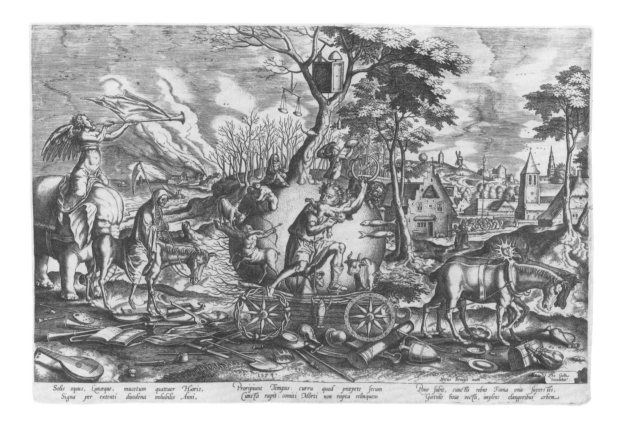

Solis equus, Lunæque, mucetum quattuor Horis, Proripiunt Tempus: curru quod præpete secum Pone subit, cunctis rebus Fama vna superstes,
Signa per extenti duodena volubilis Anni, Cuncta rapit: comiti Morti non rapta relinquens Gætulo boue vecta, implens clangoribus orbem.

51 *The Triumph of Time,* 1574

Perhaps after a composition by Bruegel
Engraving by Philipp Galle

*The horse of the sun and that of the moon rush Time forward; who, borne by the four seasons through the
twelve signs of the rotating extensive year, bears off all things with him as he goes on his swift chariot, leav-
ing what he has not seized to his companion Death. Behind them follows Fame, sole survivor of all things,
borne on an elephant, filling the world with her trumpet blasts.*

The Triumph of Time was a popular subject in the Renaissance, inspired in part by a poem by the four-
teenth-century Italian humanist Francesco Petrarch, the *Trionfi.* The central figure of Bruegel's composi-
tion is Saturn, known as Cronos in Greek mythology. He is depicted devouring his small child to pre-
vent him from later usurping his throne. Confusion between the word Cronos (God) and Chronos
(Time) perpetuated an association between Saturn and Time. Eventually, the story of Saturn devouring
his children became a metaphor for Time devouring its own offspring, the theme presented in this
engraving.

52 *Skating before the Saint George's Gate, Antwerp*, 1559-60

After a drawing of 1558 or 1559
Engraving by Frans Huys

In this engraving, skaters and skating become a metaphor for human existence, slippery and often diffi-
cult to navigate. Bruegel depicts skaters in various states of progress, embodying the twists and turns of
life. Several skate smoothly, some struggle to stay upright, and others have fallen through the ice, hang-
ing precariously between life and death. It has been proposed that this print comments on a 1553 scan-
dal involving Saint George's Gate. A portion of Antwerp's newly built fortifications, shown in the print,
was improperly financed. The ensuing scandal caused embarrassment to many prominent citizens.
Their shaken positions might be represented by the figures negotiating their way across the ice.

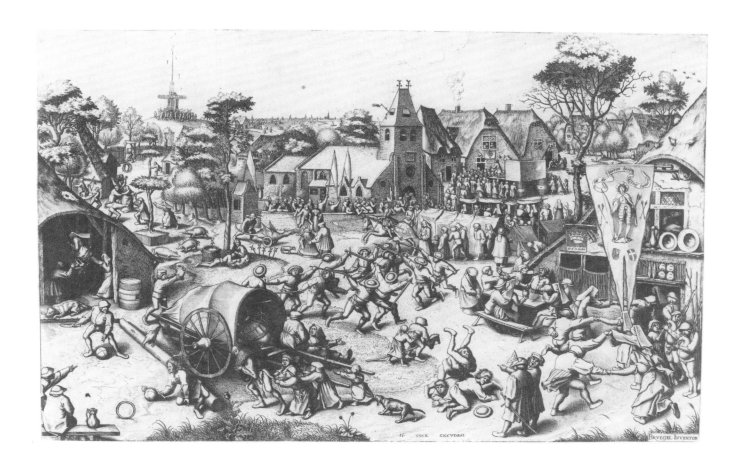

53 *The Kermis of Saint George,* c. 1559-60

Etching and engraving attributed to Jan or Lucas van Duetecum

This is in the crown or pub (?). Let the peasants have their kermis.

Though the subject of this engraving may appear to be a lighthearted, yet rambunctious peasant gathering, Bruegel's *The Kermis of Saint George* might also refer to the efforts to regulate the peasant kermises, popular rural festivals usually held in honor of a church holiday. The banner in the upper left reads, "Let the peasants hold their kermis," and seems to respond directly to an edict of Charles V, reissued in 1559, which limited the peasant celebrations. The restriction on peasant celebrations was viewed with hostility by many Flemish and seen as a direct attack on local traditions and independence.

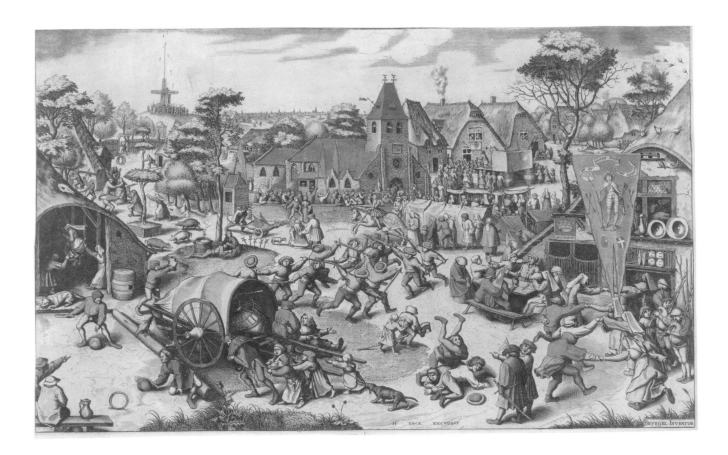

54 *The Kermis of Saint George*, c. 1559-60

Etching and engraving attributed to Jan or Lucas van Duetecum

This is in the crown or pub (?). Let the peasants have their kermis.

This subtly hand-colored impression of *The Kermis of Saint George* is a rarity in Bruegel's extant printed oeuvre. Yet records indicate that in the sixteenth century, hand-colored impressions of his prints sold for four to five times more than uncolored impressions. This is true of hand-colored impressions of *The Big Fish Eat the Little Fish* (cat. 36), sold in 1558 by Christopher Plantin to the Paris dealer Martin le Jeune.

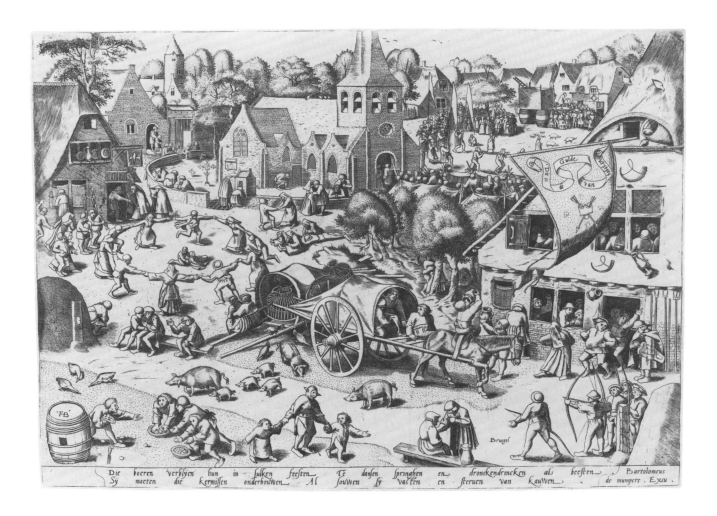

55 *Kermis at Hoboken,* c. 1559-60

After a drawing of 1559
Engraving attributed to Frans Hogenberg

This is the guild of Hoboken. The peasants rejoice at such festivals. To dance, jump, and drink themselves drunk as beasts. They must observe church festivals even if they fast and die of cold.

Hoboken was a popular destination for citizens of nearby Antwerp, who travelled there to observe and even participate in peasant celebrations. Tourists from Antwerp are however conspicuously absent from the image. Thus it has been argued that the engraving shows what the kermis would be like if government edicts restricting such celebrations to a village's inhabitants were to be enforced. The engraving allows a microcosmic inspection of peasant activities and emphasizes the gluttonous and lecherous among the throng.

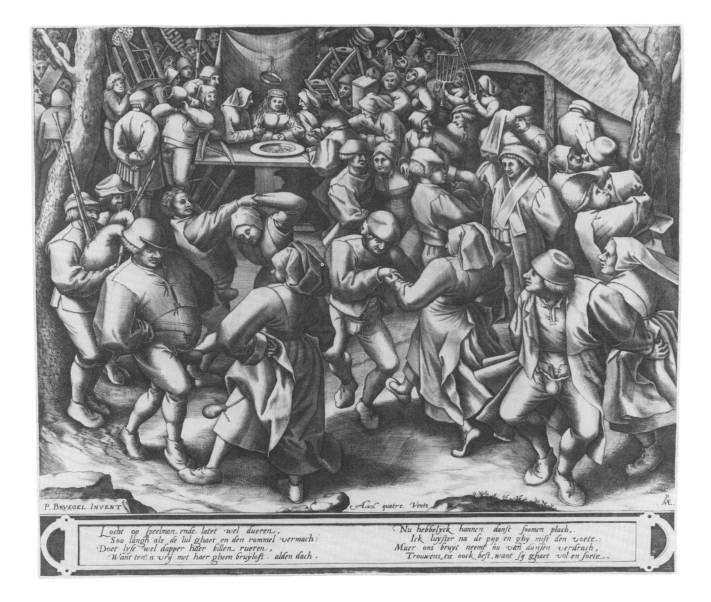

Locht op speelman ende latet wel dueren,
Soo langh als de lul ghaet en den rommel vermach:
Doet lyse wel dapper haer billen rueren,
Want ten is vry met haer gheen bruyloft, alden dach.

Nu hebbelyck hannen danst soomen plach,.
Ick luyster na de pyp en ghy mist den voete,.
Maer ons bruyt neemt nu van dansen verdrach,
Trouwens, tis oock best, want sy ghaet vol en soete.

56 *Peasant Wedding Dance,* after 1570

Probably after a painting of 1566
Engraving by Pieter van der Heyden

Keep it up musicians and make it last. So long as the flute and drum play, Liz will pluckily move her rump, because her wedding is not everyday. Tricky Dicks are doing fancy steps; I'm listening to the fife and you've missed a beat. But our bride has given up dancing, which by the way is for the best, because she's full and sweet.

Bruegel's ability to capture the gestures, expressions, and emotional states of the peasants suggests that he may have studied the peasant population from life. However, a debate persists over Bruegel's attitude toward his peasant subjects, some arguing that the artist was highly critical and others that he was celebratory. One may view *Peasant Wedding Dance* as a warning against gluttony and lust, particularly because the bride mentioned in the inscription is "full and sweet" (pregnant). However, it has also been argued that Bruegel's depictions of peasant festivities celebrate native traditions in a time of increasing infringement by Spain on the independence of the Netherlands.

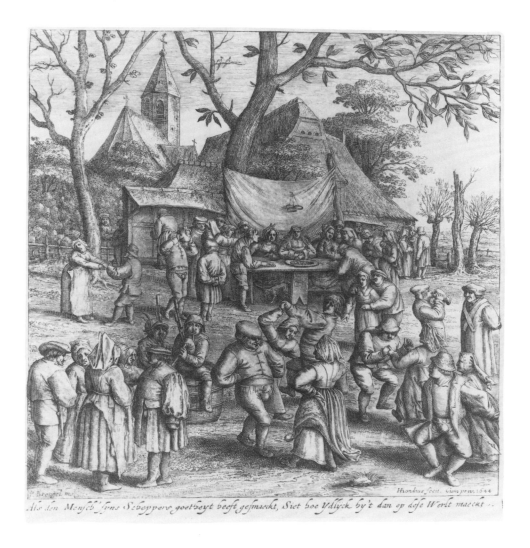

Als den Mensch syns Scheppers goetheyt heeft gesmaeckt, Siet hoe Ydlyck hy't dan op dese Werlt maeckt .

57 *Rustic Wedding Dance,* 1644

Probably a pastiche of works by Bruegel
Engraving by Hendrik Hondius

When a man has tasted of his Creator's goodness, see how vainly he then acts in this world.

While the attribution of *Rustic Wedding Dance* to Bruegel has been disputed by many scholars, others consider it part of a suite inspired by Bruegel and published by Hendrik Hondius, which also includes *Two Carnival Fools* and *Three Carnival Fools Playing with Scepters* (cat. 61 and 62). This print lacks the compact and vigorous composition of Bruegel's designs. However, it is at least a pastiche of certain works by Bruegel. Several of the dancing couples, including the central pair, are drawn from Bruegel's *Peasant Wedding Dance* (cat. 56), and the background resembles Bruegel's drawing *The Beekeepers* (in the Kupferstichkabinett, Berlin), with its quaint thatched cottage and country church.

58 *The Masquerade of Ourson and Valentin*, 1566

Anonymous woodcut

The only woodcut made after a Bruegel design, *The Masquerade of Ourson and Valentin* depicts the performance of a popular play, complete with background figures collecting money for the performers. Ourson and Valentin were twin brothers abandoned as infants. While Valentin received a courtly upbringing, Ourson was raised by bears and became a wildman. Reunited as adults, Valentin and Ourson became comrades. The stylized line of the print may reveal the difficulty of translating Bruegel's detailed and finely rendered designs into the woodcut medium, but it also underlines the contrived and more rigid appearance of performers on a stage as distinguished from natural human activity.

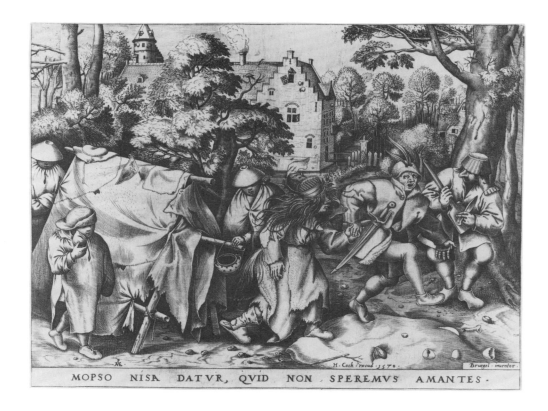

MOPSO NISA DATVR, QVID NON SPEREMVS AMANTES·

59 *The Wedding of Mopsus and Nisa*, 1570

After a drawing of c. 1566
Engraving by Pieter van der Heyden

Mopsus marries Nisa; what may not we lovers hope for?

Originally begun as a woodcut, for which a partially carved block still exists (in The Metropolitan Museum of Art, New York), *The Wedding of Mopsus and Nisa* was later engraved by Pieter van der Heyden. The story of Mopsus and Nisa, from the eighth eclogue of the Roman poet Virgil (70-19 B.C.), is depicted by Bruegel in the contemporary Flemish countryside, with Mopsus and Nisa transformed from mythical lovers to laughably crude and slovenly peasants. The story of Mopsus and Nisa, like that of Ourson and Valentin (cat. 58), was the basis of a popular play at Flemish fairs and carnivals. Here, Bruegel may have been illustrating the subject in an overblown and humorous manner, as it was staged in pageants, where the crudely featured "bride" was led toward the nuptial tent after eating a meager party feast. Remnants of bones and rotting vegetables are still at the bride's feet.

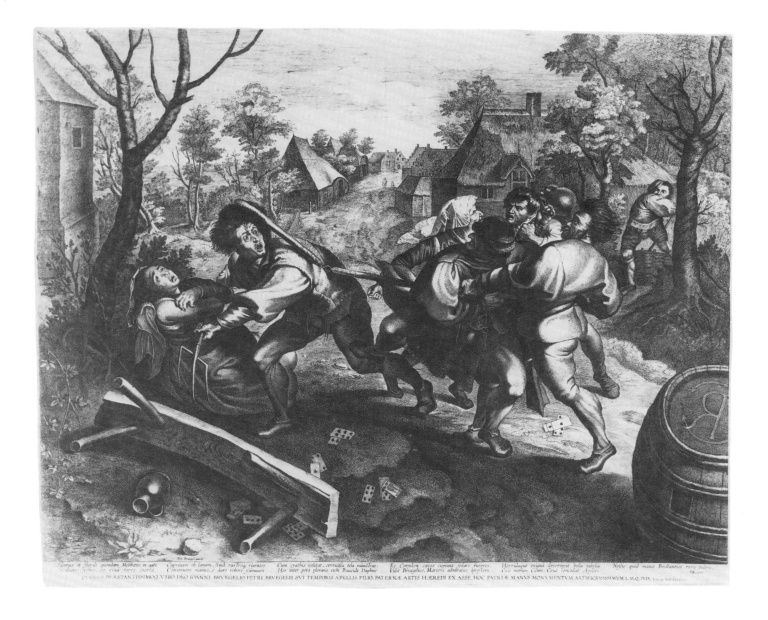

60 *Peasants' Brawl over a Game of Cards,* c. 1620

After a lost drawing by Bruegel or a copy of that drawing by Peter Paul Rubens
Etching and engraving by Lucas Vorsterman

Once in a barren field Tityrus and Meliboeus grew excited in their cups, and, by chance, a quarrel arose over nothing, and, unyielding, plow-handle and rake they took into their hands; a bench of hard oak with jugs flies, beer furnishes weapons. Between these (two), Daphne, wailing with drunken Baucis, and Corydon desire to calm blind fury. Bruegel saw, he wondered at savage Mars and he portrayed the frightful battles in a small painting. Yield Coan wine, let Coan Apelles concede: the Brabantine country has produced something extraordinarily greater. To the most renowned and outstanding man, Master Jan Bruegel, the son of Pieter Bruegel, the Apelles of his age, sole heir of his father's art, L.M.Q. has dedicated this most ingenious monument of the paternal skill.

This image refers to the more negative aspects of peasant life, employing the rapid compositional motion from right to left and the peasants' swarthy, contorted facial features to emphasize the violence of their brawl. The inscription mockingly names the brawling peasants after shepherds, peasants, and other personages in ancient mythology.

61 *Two Carnival Fools,* 1642

 In the manner of Bruegel
 Engraving by Hendrik Hondius

62 *Three Carnival Fools Playing with Scepters,* 1642

 In the manner of Bruegel
 Engraving by Hendrik Hondius

Though the attribution of these images to Bruegel has been disputed, since no original designs exist, they nonetheless bear similarities to many of his later works. Particularly characteristic of Bruegel is the combination of facial expression and physical action to relay the essence of the subject. These prints correspond chronologically with another series after Bruegel published by Hendrik Hondius that depicts the facial and physical manifestations of epilepsy. They also recall images such as *The Witch of Mallegem* (cat. 44), in which absurd physiognomy, such as long, crooked noses and jutting chins, depict gullible and foolish individuals.

63 Rascal Without-Pity

Perhaps after a lost drawing by Bruegel of c. 1564-65
Etching attributed to Jan or Lucas van Duetecum

64 Aecht Without-Soul

Perhaps after a lost drawing by Bruegel of c. 1564-65
Etching attributed to Jan or Lucas van Duetecum

Though the attribution of the *Suite of Heads of Peasant Men and Women Showing Different Expressions* to Bruegel has been questioned by some scholars, the images nevertheless reflect Bruegel's style in 1564-65, and may derive from lost studies by the artist. These heads show the power of Bruegel to grasp and emphasize the essential features of the face, a quality evident in later Bruegel designs such as *Peasants' Brawl over a Game of Cards* (cat. 60). With accompanying inscriptions, the series of peasant heads, of which these two prints are a part, derived its humor from a belief reaching back into antiquity that a man or woman's facial features reflected his or her character. However inscriptions that assign a specific character to each of the peasant heads were not published until 1658.

65 *A Man Yawning*

After a painting by Bruegel of c. 1564
Etching and engraving attributed to Lucas Vorsterman

In many of Bruegel's earlier compositions the individual facial features of the peasants are subordinated to their characteristic movements. However, by the 1560s Bruegel's interest in human facial expression had increased significantly. *A Man Yawning*, based on a painting owned by Peter Paul Rubens and now lost, explores in detail the physical manifestations of a yawn, including the open mouth, furrowed brow, and tense facial muscles. The design for this print has also been discussed as a representation of Sloth.

Glossary of Latin Terms and Abbreviations Found in the Inscriptions

The translations of the inscriptions on the prints are for the most part taken from or based on Freedberg, et al., 1989. In the case of catalogue numbers 2, 17, 45, 57, and 60, the translations are taken from or based on Bastelaer, rev. ed., 1992. Christian B. Peper, Sr. provided the translations of the inscriptions of catalogue numbers 11, 49, and 50 and of a part of the inscription of catalogue number 60 not translated in Freedberg or Bastelaer.

cum privilegio - "With permission." Also abbreviated or written: c: privil., cu. priui., cum prae., cum priuil., cvm privileg, cum priv., cum priuileg., cvm privilegio, cum priuilegio.

cum gratia et priuilegio - "With favor and permission."

excudebat, excvdebat. - "Struck out" or "made." Conventionally used to indicate the publisher of the print. Also abbreviated: exc, excu., excv., excud., excvd., excude., excudeb.

fecit - "Made" or "did." Also abbreviated: fec.

invenit, inventor - "Invented" or "inventor." Used to refer to the artist whose image is being reproduced in the print. Also abbreviated or written: inu, inv., inue, inve, inuen., inven., in.ven., inuent., invent., inuet., inuentor.

pictor, pinxit - "Painter" or "painted." Used to refer to the artist whose original painting the print reproduces.

sculpsit, sculpebat - "Carved." Originally used for pure engravings, the term came to be used on images that were etched as well as engraved. Also abbreviated: sc.

CHECKLIST

1 *The Rabbit Hunt,* 1560
Etching by Pieter Bruegel, Bastelaer I
215 x 291 mm (trimmed below to image)
In the lower left corner: BRVEGEL 1506 (the date is barely readable underneath the lines at the base of the tree, and the last two digits of the date are transposed); in the sky at right: H. Cock excu.

2 *River Landscape with Mercury and Psyche,*
1580 or before
After a drawing of 1553
Etching and engraving attributed to Joris Hoefnagel or Simon Novellanus, Bastelaer 1
270 x 342 mm
In the lower margin: ARTI ET INGENIO STAT SINE MORTE DECVS.; and below this: Pulcher Atlantiades Psÿchen ad Sydera tollens, / Ingenio scandi sÿdera posse docet. / Ingenio liquidum possim consendere Coelum, / Si mundi curas fata leuare velint.; and below: Petrus Bruegel fec: Romae A° (Anno, in the year): 1553. / Excud: Houf: cum prae: Caes°:

3 *Landscape with the Temptation of Christ,*
c. 1555
After a drawing of 1554
Etching and engraving by Hieronymus Cock, Bastelaer 2b
226 x 351 mm
On the lower left: H. Cock. fecit., below: NON IN SOLO PANE VICTVRVS EST HOMO, SED OMNI VERBO QVOD DIGREDITVR PER OS DEI. MAR. 4. DEVT. 8.

4 *View of the Tibur* **(Tivoli),** c. 1555-56
(PROSPECTVS TYBVRTINVS)
Etching and engraving by Jan and Lucas van Duetecum, Bastelaer 3
322 x 427 mm
In the lower right corner: h. cock excude.; in the middle of the lower margin: PROSPECTVS TYB-VRTINVS (The S's in "PROSPECTVS" are backwards).

5 *Saint Jerome in the Wilderness,* c. 1555-56
(S. HIERONYMVS IN DESERTO)
Etching and engraving by Jan and Lucas van Duetecum, Bastelaer 7
322 x 422 mm
In the lower right corner: brueghel Inue; and below this: h. cock excu.; in the lower margin: S. HIERONYMVS IN DESERTO.

6 *The Penitent Magdalene,* c. 1555-56
(MAGDALENA POENITENS)
Etching and engraving by Jan and Lucas van Duetecum, Bastelaer 8
322 x 422 mm
In the lower left corner: brueghel Inuen; and below this: h. cock excud.; in the lower margin: MAG-DALENA POENITENS.

7 *Rustic Solicitude,* c. 1555-56
(SOLICITVDO RVSTICA)
Etching and engraving by Jan and Lucas van Duetecum, Bastelaer 12
322 x 421 mm
In the lower middle foreground: brueghel Inue; below this: H. cock excu.; in the lower margin: SOLICITVDO RVSTICA.

8 *Wooded Region,* c. 1555-56
(PAGVS NEMOROSVS)
Etching and engraving by Jan and Lucas van Duetecum, Bastelaer 16
321 x 425 mm
In the lower left corner: brueghel inue; to the right of this and towards the center: h. cock excu.; in the lower margin: PAGVS NEMOROSVS.

9 *Soldiers at Rest,* c. 1555-56
(MILITES REQVIESCENTES)
Etching and engraving by Jan and Lucas van Duetecum, Bastelaer 17
321 x 424 mm
At the bottom, toward the left: bruegel inu (short line below n and u); in the lower right corner: h.

cock excu.; in the lower margin: MILITES (the second "I" is smaller and interposed between the "L" and the "T") REQVIESCENTES.

10 *Large Alpine Landscape*, c. 1555-56
Etching and engraving by Jan and Lucas van Duetecum, Bastelaer 18
368 x 468 mm
In the lower right corner: BRVEGHEL INVE; below this: H. cock excudeb. (A crack at the lower right passes through the last letters.)

11 *Naval Battle in the Strait of Messina*, 1561
Based in part on drawings of c. 1552-53
Engraving by Frans Huys, Bastelaer 96
425 x 715 mm
In the upper margin: FRETI SICVLI SIVE MAMERTINI VVLGO EL FARO DI MESSINA OPTICA DELINEATIO.; in the sky at the left: REZO (i.e., Reggio in Calabria) and to the right: MESSINA.; in the lower right corner, in the cartouche, the following four couplets: Trinacriae insignes portum'que vrbem' que vetustam / Messanam, veteres quam construxere Pelasgi, / Parte vides dextrae & scopulos, sedesque Gigantun / Qua micat horrendum nocturnis ignibus Æthna. / Rhegius a'laeua est Calabrùm traiectus: at illud / Inter vtrumque fretum Scylla terribile monstro / Olim terra fuit, quae post quassata dehiscens / Ionium excepit Pelagus, factum'que barathrum.; below this: HieronymuS Cock pictor excudebat, M.D. lxi / Cum Gratia et priuilegio. / Bruegel Inuen.; in the lower left corner: F. HVIIS. FECIT.

12 *A Dutch Hulk and a Boeier*, 1565
Engraving attributed to Frans Huys, Bastelaer 98
240 x 194 mm
Without the artists' or publisher's names. At the bottom, toward the left, the date 1565; on the stern of the larger ship, barely engraved, in small characters: Dit scip 1564.

13 *Three Caravels in a Rising Squall with Arion on a Dolphin*, c. 1560-62
Engraving by Frans Huys, Bastelaer 105

220 x 286 mm
In the lower left corner: the initials of the engraver: F.H.; next to this: bruegel; in the lower margin, to the right: Cum. priuileg.

14 *Two Galleys Sailing behind an Armed Three-Master with Phaëthon and Jupiter in the Sky*, c. 1560-63
Engraving attributed to Frans Huys or Cornelis Cort, Bastelaer 106
223 x 278 mm

15 *Christ and the Woman Taken in Adultery*, 1579
After a grisaille painting of 1565
Engraving by Pieter Perret, engraver's signature lower edge, left of center, Bastelaer 111
265 x 345 mm
Inscribed lower left: BRVEGEL. M.D. LXV. (indicating the date of the painting rather than the engraving); further to the right: P. Perret sc [ulpsit] 79 (i.e. 1579); on lower right: Cum Priuilegio.; on the stone in front of Christ, in Flemish: DIE SONDER SONDE IS / DIE; on lower margin: QVI SINE PECCATO EST VESTRVM, PRIMVS IN ILLAM LAPIDEM MITTAT. Ioan. 8.; followed by the identification of the publisher, Pierre de Jode of Antwerp: Antverpiae apud Petrum de Iode.

16 *The Resurrection*
After a monochrome wash drawing of c. 1562
Engraving attributed to Philipp Galle, Bastelaer 114
465 x 328 mm
Inscribed lower left: BRVEGEL INVEN. / COCK. EXCVDEBAT.

17 *The Death of the Virgin*, 1574
After a grisaille painting of c. 1564
Engraving by Philipp Galle, Bastelaer 116
310 x 417 mm
Inscribed lower margin, in cartouche on left: Sic Petri Brugelij / archetÿpu [m]. Philipp. / Galleus imitabatur; in cartouche on the right: Abrah. Ortelius, / sibi & amicis, / fieri curabat.; in the lower margin in three Latin quatrains: Gnati regna tui Virgo cum regna petebas / Complebant pectus

gaudia quanta tuum? / Quid tibi dulce magis fuerat quam carcere terre / Migrare optati in templa superna poli? / Cumque sacram turbam, fueras cui presidium tu, Linquebas, nata est que tibi maestitia / Quam mestus quoque, quam letus spectabat eunte / Te, nati atque idem grex tuus ille pius? / Quid magis his gratum, quam te regnare, quid eque / Triste fuit, facie quam caruisse tua? / Mestitie letos habitus, vultus'que proborum / Artifici monstrat picta tabella manu.

18 *The Temptation of Saint Anthony*, 1556
Engraving attributed to Pieter van der Heyden, Bastelaer 119
245 x 320 mm
Inscribed lower left: Cock. excud. 1556; on lower margin, in Latin: MVLTÆ TRIBVLATIONES IVSTORVM, DE OMNIBVS IIS LIBERABIT EOS DOMINVS. PSAL. 33. (The engraved inscription gives the Vulgate numbering.)

19 *The Last Judgment*, 1558
After a drawing of 1558
Engraving by Pieter van der Heyden, engraver's monogram lower right, Bastelaer 121
225 x 295 mm
Inscribed lower left: Brueghel. inuet; slightly further to the right: H. Cock. excude. cum. priuileg. 1558; on lower margin, in Latin: VENITE. BENEDICTI. PATRIS. MEI. IN. REGNVM. AETERNVM. / ITE. MALEDICTI. PATRIS. MEI. IN. IGNEM. SEMPITERNVM.; and in Flemish: Compt ghÿ ghebenedÿde mÿns vaders hier / En ghaet ghÿ vermaledÿde in dat eewighe vier.

20 *The Parable of the Good Shepherd*, 1565
Engraving by Philipp Galle, engraver's monogram on blade of axe, Bastelaer 122
225 x 295 mm
Inscribed lower left: BRVEGEL. IN.VEN.; below the doorpost the date 1565; on the lintel of the door, in Latin: EGO SVM OSTIVM OVIVM.; and above this the source: IOHA. 10; on the lower margin, in Latin: HIC TVTO STABVLATE VIRI, SVCCEDITE TECTIS; / ME PASTORE OVIVM, IANVA LAXA PATET. / QVID LATERA, AVT CVLMEN PERRVMPITIS? ISTA LVPORVM, /

ATQVE FVRVM LEX EST, QVOS MEA CAVLA FVGIT. HAD [rianus] IVN [ius].

21 *The Parable of the Wise and Foolish Virgins*, c. 1560-63
Engraving attributed to Philipp Galle, Bastelaer 123
221 x 286 mm
Inscribed lower left edge: H. cock excu.; lower right corner: BRVEGEL. INV.; on lower margin, in Latin: DATE NOBIS DE OLEO VESTRO, QVIA LAMPADES NOSTRAE EXTINGVNTVR. NEQVAQVAM, NEQVANDO NON SVFFICIAT NOBIS ET VOBIS math. 25.; on the banderole in front of the angel: Ecce sponsus uenit exit[e] obuiam ei.; on the wall to the right: Non noui uos.

22 *Anger* (**Ira**), 1558
After a drawing of 1557
Engraving by Pieter van der Heyden, engraver's monogram lower center, Bastelaer 125
223 x 296 mm
Inscribed lower left: P. brueghel. Inuentor; lower right: H. cock. excude. Cum gratia et priuilegio. 1558; underneath the allegorical figure: IRA; on the lower margin, in Latin: ORA TVMENT IRA, NIGRESCVNT SANGVINE VENÆ.; and in Flemish: Gramscap doet den mont swillen / en verbittert den moet sij beroert den gheest / en maeckt swert dat bloet.

23 *Sloth* (**Desidia**), 1558
After a drawing of 1557
Engraving by Pieter van der Heyden, engraver's monogram lower center, Bastelaer 126
225 x 292 mm
Inscribed lower left: brueghel. Inuentor.; lower right: H. Cock. excud. cum priuileg. 1558; underneath the allegorical figure: DESIDIA; on lower margin, in Latin: SEGNITIES ROBVR FRANGIT, LONGA OCIA NERVOS.; and in Flemish: Traechheÿt maeckt machteloos / en verdroocht Die senuwen dat de mensch niewers toe en doocht.

24 *Pride* (**Superbia**), 1558
After a drawing of 1557

Engraving by Pieter van der Heyden, engraver's monogram lower center, Bastelaer 127
225 x 292 mm
Inscribed lower left: Cock excud cum priuileg 1558; lower right: P. brueghel. Inuentor.; underneath the allegorical figure: SVPERBIA; on the lower margin, in Latin: NEMO SVPERBVS AMAT SVPEROS, NEC AMATVR AB ILLIS.; and in Flemish: Houerdÿe werdt van godt bouen al ghehaet Tseghelÿx werdt godt weder van houerdÿe versmaet.

25 *Avarice* **(Avaritia),** 1558
After a drawing of 1556
Engraving by Pieter van der Heyden, engraver's monogram lower center, Bastelaer 128
224 x 293 mm
Inscribed lower left: P. brueghel. Inuentor.; to the right: Cock. excud. cum priuileg, 1558; underneath the allegorical personification: AVARITIA; on the lower margin, in Latin: QVIS METVS, AVT PVDOR EST VNQVAM PROPERANTIS AVARI?; and in Flemish: Eere, beleeftheÿt, scaemte noch godlÿck vermaen En siet die scrapende ghierichheÿt niet aen.

26 *Gluttony* **(Gula),** 1558
After a drawing of 1557
Engraving by Pieter van der Heyden, engraver's monogram lower center, Bastelaer 129
223 x 293 mm
Inscribed underneath the allegorical personification: GVLA; on the overturned feeding tub: brueghel Inuentor; in the lower right: H. Cock. excud cum gratie et priuilegio. 1558; on the lower margin, in Latin: EBRIETAS EST VITANDA, INGLVVIESQVE CIBORVM.; and in Flemish: Schout dronckenschap en gulsichlÿck eten Want ouerdaet doet godt en hem seluen vergheten.

27 *Envy* **(Invidia),** 1558
After a drawing of 1557
Engraving by Pieter van der Heyden, engraver's monogram lower center, Bastelaer 130
227 x 295 mm
Inscribed lower left: brueghel. Inuet.; further to the right: Cock. excud. cum priuil.; underneath the allegorical personification: INVIDIA; on the lower margin, in Latin: INVIDIA HORRENDVM MONSTRVM, SÆVISSIMA PESTIS.; and in Flemish: Een onsterffelijcke doot es nijt en wreede peste Een beest die haer seluen eet met valschen moleste.

28 *Lust* **(Luxuria),** 1558
After a drawing of 1557
Engraving by Pieter van der Heyden, engraver's monogram lower center, Bastelaer 131
225 x 295 mm
Inscribed lower left: brueghel. Inuentor. / H. Cock. excu. cu. priui.; underneath the allegorical figure: LVXVRIA; on the lower margin, in Latin: LVXVRIA ENERVAT VIRES, EFFOEMINAT ARTVS.; and in Flemish: Luxurÿe stinckt, sÿ is vol onsuuerheden Sÿ breeckt die Crachten, en sÿ swackt die leden.

29 *Faith* **(Fides),** 1559-60
After a drawing of 1559
Engraving attributed to Philipp Galle, Bastelaer 132
223 x 287 mm
Inscribed lower left: Cock exc; underneath the allegorical personification: FIDES; lower right: Brugel Inu; on lower margin, in Latin: FIDES MAXIME A NOBIS CONSERVANDA EST PRAECIPVE IN RELIGIONEM, / QVIA DEVS PRIOR ET POTENTIOR EST QVAM HOMO.

30 *Hope* **(Spes),** 1559-60
After a drawing of 1559
Engraving attributed to Philipp Galle, Bastelaer 133
223 x 288 mm
Inscribed lower left: BRVGEL. INV; underneath the allegorical figure: SPES; lower right: H. cock excu.; on lower margin, in Latin: IVCVNDISSIMA EST SPEI PERSVASIO, ET VITAE IMPRIMIS / NECESSARIA, INTER TOT AERVMNAS PENEQVE INTOLERABILES.

31 *Charity* **(Charitas),** 1559
After a drawing of 1559
Engraving attributed to Philipp Galle, Bastelaer 134

222 x 289 mm
Inscribed lower edge, left of center: H. cock
excude; underneath the allegorical figure: CHARI-
TAS; lower right: BRVEGEL. 1559; on lower mar-
gin, in Latin: SPERES TIBI ACCIDERE QVOD
ALTERI ACCIDIT, ITA DEMVM EXCITABERIS
AD OPEM FERENDAM / SI SVMPSERIS EIVS
ANIMVM QVI OPEM TVNC IN MALIS CON-
STITVTVS IMPLORAT.

32 *Justice* **(Iustitia)**, 1559-60
After a drawing of 1559
Engraving attributed to Philipp Galle,
Bastelaer 135
223 x 287 mm
Inscribed underneath the allegorical figure: IVSTI-
CIA; on lower margin, in Latin: SCOPVS LEGIS
EST, AVT VT EV[M] QVE[M] PVNIT EMENDET,
AVT POENA / EIVS CAETEROS MELIORES
REDDET AVT SVBLATIS MALIS CAETERI
SECVRIORES VIVAT.

33 *Prudence* **(Prudentia),** 1559-60
After a drawing of 1559
Engraving attributed to Philipp Galle,
Bastelaer 136
225 x 293 mm
Inscribed lower edge, left of center: H. cock excu.;
underneath the allegorical figure: PRVDENTIA;
lower right: Bruegel. Inuentor; on lower margin,
in Latin: SI PRVDENS ESSE CVPIS, IN FVTVRVM
PROSPECTVM OSTENDE, ET / QVAE POSSVNT
CONTINGERE, ANIMO TVO CVNCTA PRO-
PONE.

34 *Fortitude* **(Fortitudo),** 1560
After a drawing of 1560
Engraving attributed to Philipp Galle,
Bastelaer 137
223 x 287 mm
Inscribed lower left: COCK EXC; underneath the
allegorical figure: FORTITVDO; lower right:
BRVEGEL INVENTOR; on the lower margin, in
Latin: A NIMVM VINCERE, IRACVNDIAM
COHIBERE, CAETERAQVE VITIA ETAFFECTVS
/ COHIBERE, VERA FORTITVDO EST.

35 *Temperance* **(Temperantia)**, 1560
After a drawing of 1560
Engraving attributed to Philipp Galle,
Bastelaer 138
223 x 287 mm
Inscribed lower right: BRVEGEL; on the dress hem
of the allegorical figure: TEMPERANTIA; on the
lower margin, in Latin: VIDENDVM, VT NEC
VOLVPTATI DEDITI PRODIGI ET LVXVRIOSI /
APPAREAMVS, NEC AVARA TENACITATI SOR-
DIDI AVT OBSCVRI EXISTAMVS.

36 *The Big Fish Eat the Little Fish*, 1557
After a drawing of 1556
Engraving by Pieter van der Heyden, engraver's
monogram lower left, Bastelaer 139
229 x 296 mm
Inscribed lower left: Hieronÿmus: Bos. / inuentor;
lower right: COCK. EXCV. 1557; on lower margin,
in Latin: GRANDIBVS EXIGVI SVNT PISCES PIS-
CIBVS ESCA.; and in Flemish: Siet sone dit hebbe
ick zeer langhe gheweten dat die groote vissen de
cleÿne eten.

37 *The Battle of the Moneybags and the
Strongboxes*, after 1570
Engraving by Pieter van der Heyden, engraver's
monogram lower center, Bastelaer 146
236 x 304 mm
Inscribed lower right: P. Bruegel Inuet; slightly to
the left: Aux quatre Vents.; on the lower margin, in
Latin: Quid modo diuitie, quid fului vasta metalli
/ Congeries, nummis arca referta nouis /
Illecebres inter tantas, atq [ue] agmina furum, /
Inditium cunctis efferus vncus erit, / Preda facit
furem, feruens mala cuncta ministrat / Impetus, et
spolijs apta rapina feris.; and in Flemish: Wel aen
ghÿ Spaerpotten, Tonnen, en Kisten. / Tis al om
gelt en goet, dit striden en twisten. / Al seetmen v
ooc anders, willet niet ghelouen. / Daerom vuere
wÿ den haec die ons noÿt en miste, / Men soeckt
wel actie om ons te uerdoouen, / Maer men souw-
er niet krÿgen, waerder niet te roouen.

38 *The Land of Cockaigne*
Based on a painting of 1567
Engraving attributed to Pieter van der Heyden,

Bastelaer 147

208 x 276 mm

In the cartouche at the lower right: P. Breugel [sic] / inuentor.; without the name of the publisher or engraver; in the lower margin: Die daer luÿ en lacker sÿt boer crÿsman oft clercken / die gheraeckt daer en smaeckt claer van als sonder werken / Die tuÿnen sÿn worsten die huÿsen met vlaÿen / cappuÿnen en kieckens tvleichter al ghebraÿen.

39 *The Merchant Robbed by Monkeys,* 1562
Engraving by Pieter van der Heyden, engraver's monogram below the drum in the lower right, Bastelaer 148

225 x 290 mm

Inscribed lower left: BRVEGHEL INVE; lower center: H. Cock. excu. 1562.

40 *Everyman,* c. 1558
After a drawing of 1558
Engraving attributed to Pieter van der Heyden, Bastelaer 152

228 x 294 mm

Inscribed lower right: H. COCK. EXCVD. CVM. PRIVILEG; on the coat hems of the five old men: ELCK (Everyman); on the lower margin, in Latin: Nemo non quaerit passim sua commoda, Nemo / Non querit sese cunctis in rebus agendis, / Nemo non inhiat priuatis vndique lucris, / Hic trahit, ille trahit, cunctis amor vnus habendi est.

41 *The Thin Kitchen,* 1563
Engraving by Pieter van der Heyden, Bastelaer 154

220 x 290 mm

In the lower right corner: brueghel inue 1563; near the center, the monogram of the engraver; in the lower margin, two distichs, one in French, the other in Dutch: Ou Maigre-os Le pot mouue, est vn (un) pouure Conuiue / Pource, á Grasse-cuisine iray, tant que ie Viue / Daer magherman die pot roert is een arm ghasterije / dus Loop ick nae de uette Cuecken met herten blije.

42 *The Fat Kitchen,* 1563

Engraving by Pieter van der Heyden, Bastelaer 159

220 x 292 mm

Near the upper right corner: pieter brueghel inue; in the lower left corner: H. Cock excudeb; at bottom, slightly to the left of the middle: 1563; and to the right of this date, the monogram of the engraver; in the lower margin, two distichs, one in French, the other in Dutch: Hors dici Maigre-dos á eune' hideuse mine / Tu nas que'faire ici Car cest Grasse-Cuisine / Vuech magherman uan hier hoe hongerich ghÿ siet / Tis heir al uette Cuecken ghi en dient (the e under the i) hier niet.

43 *The Misanthrope Robbed by the World,*
perhaps c. 1568
Based on a painting of 1568
From the *Suite of Twelve Flemish Proverbs*
Engraving by Jan Wierix, engraver's monogram underneath the figure of the Misanthrope, Bastelaer 171

179 mm in diameter

Inscribed next to the head of the Misanthrope: Je porte dueil voÿant le monde, / Qui en tant de fraudes abonde.; and in a circle around the composition, in Flemish: De sulck draecht rou-om dat de Weerelt is onghetrou, Die meeste ghebruijcken minst recht en reden, Weijnich leefter nou-also hij leuen sou, Men rooft men treckt elck steeckt vol gheueijsde seden.

44 *The Witch of Mallegem,* 1559
Engraving by Pieter van der Heyden, engraver's monogram on the right leg of the bench in the foreground, Bastelaer 193

355 x 480 mm

Lower center: H. COCK. EXCVD. CVM PRIVILEGIO. 1559.; at the right, on the cartouche: P. brueghel / inuentor.

45 *The Festival of Fools,* after 1570
Probably after a drawing of c. 1568
Engraving by Pieter van der Heyden, Bastelaer 195

325 x 437 mm

In the lower left corner: P: Brueghel Inuentor; next to this: the monogram of the engraver; in the center, the address: Aux quatre Vents.; in the lower margin, four Flemish quatrains: Ghÿ Sottebollen, die met ÿdelheÿt, ghequelt sÿt, / Compt al ter banen, die lust hebt om rollen, / Al wordet deen sÿn eere en dander tgelt quÿt, / De weerelt die prÿst, de grootste Sottebollen. / Men vint Sottebols, onder elcke nacie, / Al en draghen sÿ geen sotscappen, op haeren cop, / Die int dansen hebben, al sulcken gracie, / Dat hunnen Sottebol, draÿet, ghelÿck eenen top. / De vuÿlste Sottebols, lappent al duer de billen, / Dan sÿnder, die d'een dander, metten nuese vatten, / De sulck, vercoopt trompen, en dander brillen, / Daer sÿ veel, Sottebollen, mede verschatten. / Al sÿnder Sottebols, die haer wÿsselÿck draghen, / En van tSottebollen, den rechten sin smaken, / Om dat sÿ in hun selfs sotheÿt hebben behagen / Sal hueren Sottebol alderbest de pin raken.

46 *The Alchemist,* probably 1558
After a drawing of 1558
Engraving attributed to Philipp Galle,
Bastelaer 197
339 x 446 mm
Inscribed upper left: Brueghel Inue; lower edge, towards the left: H. COCK EXCVD CVM PRIVI-LEGIO; on margin below, in two columns, in Latin: DEBENT IGNARI RES FERRE ET POST OPERARI / IVS LAPIDIS CARI VILIS SED DENIQVE RARI / VNICA RES CERTA VILIS SED VBIQVE REPERTA / QVATVOR INSERTA NATVRIS IN NVBE REFERTA / NVLLA MINER-ALIS RES EST VBI PRINCIPALIS / SED TALIS QVALIS REPERITVR VBIQVE LOCALIS.

47 *Spring,* 1570
After a drawing of 1565
Engraving by Pieter van der Heyden,
Bastelaer 200
228 x 287 mm
In the lower left corner: Bruegel. inuet.; to the right between the feet of the gardener: H. Cock excud. 1570.; further to the right, the monogram of the engraver; in the lower margin, to the left: Martius,

Aprilis, Maius, sunt tempora ueris.; in the middle, in a small cartouche: VER / Pueritie compar; to the right: Vere Venus gaudet florentibus aurea sertis.

48 *Summer,* 1570
After a drawing of 1568
Engraving by Pieter van der Heyden,
Bastelaer 202
225 x 283 mm
In the lower right corner: Cock excu. Bruegel Inuet.; in the lower margin at the left: Iulius, Augustus, nec non et Iunius Aestas.; in the center in a small cartouche: AESTAS / Adoles centie imago; to the right: Frugiferas aruis fert Aestas torrida messeis.

49 *Autumn,* 1570
Engraving by Pieter van der Heyden after Hans Bol
225 x 288 mm
In the lower left corner: H. Bol.; in the lower right corner: Cock. excu.; in the lower margin at the left: Septembri, Octobri Autumnus, totóque, Novembri; in the center in a cartouche: AVTVMNVS / virili-tatis tÿpus.; to the right: Dat musto grauidas Autumnus pomifer uuas.

50 *Winter,* 1570
Engraved by Pieter van der Heyden after Hans Bol
226 x 285 mm
In the lower center: H. Cock. excud. 1570.; in the lower right: H. Bol.; in the lower margin at the left: Brumales (the "r" raised) Ianus, Februarius atque December.; in the center in a cartouche: HYEMS / Senectuti comparatur.; to the right: Vis Hÿemis glacie currentes alligat undas.

51 *The Triumph of Time,* 1574
Perhaps after a composition by Bruegel
Engraving by Philipp Galle, Bastelaer 204
208 x 301 mm
Inscribed lower edge, center: 1574; towards the right: Petrus Bruegel inuen.; in a cartouche, lower right: Phs Galle / excudebat; on the lower margin, in Latin: Solis equus, Lunaeque, mucetum [i.e.

invectum] quattuor Horis, / Signa per extenti duo-
dena volubilis Anni, / Proripiunt Tempus: curru
quod praepete secum / Cuncta rapit: comiti Morti
non rapta relinquens / Pone subit, cunctis rebus
Fama vna superstes, / Gaetulo boue vecta,
implens clangoribus orbem.

**52 *Skating before the Saint George's Gate,
Antwerp,*** 1559-60
After a drawing of 1558 or 1559
Engraving by Frans Huys, Bastelaer 205
232 x 299 mm
In the lower left corner: H. cock excudeb; in the
right corner, the initials of the engraver.

53 *The Kermis of Saint George,* c. 1559-60
Etching and engraving attributed to Jan or Lucas
van Duetecum, Bastelaer 207
332 x 523 mm
At the bottom, near the middle: H. COCK EXCVD-
BAT [sic]; in the lower right corner: BRVEGEL
INVENTOR.; on the sign hanging outside the tav-
ern: Dit is in die krö; to the right, on the banner:
Laet die boeren haer kermis houuen.

54 *The Kermis of Saint George,* c. 1559-60
Etching and engraving attributed to Jan or Lucas
van Duetecum, hand-colored, Bastelaer 207
332 x 523 mm
At the bottom, near the middle: H. COCK EXCVD-
BAT [sic]; in the lower right corner: BRVEGEL
INVENTOR.; on the sign hanging outside the tav-
ern: Dit is in die krö; to the right, on the banner:
Laet die boeren haer kermis houuen.

55 *Kermis at Hoboken,* c. 1559-60
After a drawing of 1559
Engraving attributed to Frans Hogenberg,
Bastelaer 208
298 x 408 mm
On the cask in the lower left corner, the monogram
of the engraver; on the banner flying before the
end at right: Dit is de Gulde van hoboken; below,
toward the right: Bruegel; in the lower margin, to
the right of the address: Bartolomeus / de
mumpere. Excu.; and to the left, four lines of verse

in Dutch: Die boeren verblÿen hun in sulken
feesten / Te dansen springhen en dronckendrinck-
en als beesten. / Sÿ moeten die kermissen onder-
houwen / Al souwen sÿ vasten en steruen van
kauwen.

56 *Peasant Wedding Dance,* after 1570
Probably after a painting of 1566
Engraving by Pieter van der Heyden, Basetlaer 210
375 x 423 mm
In the lower left corner: P. BRVEGEL. INVENT.; in
the center of the foreground: Aux quatre Vents; in
the lower right corner, the monogram of the
engraver; in the lower margin of the third and later
states: Locht op speelman ende latet wel dueren, /
Soo langh als de lul ghaet en den rommel verma-
ch: / Doet lÿse wel dapper haer billen rueren, /
Want ten is vrÿ met haer gheen bruÿloft alden
dach. / Nu hebbelÿck hannen danst soomen plach,
/ Ick luÿster na de pÿp en ghÿ mist den voete: /
Maer ons bruÿt neemt nu van dansen verdrach, /
Trouwens, tis oock best, want sÿ ghaet vol en
soete.

57 *Rustic Wedding Dance,* 1644
Probably a pastiche of works by Bruegel
Engraving by Hendrik Hondius, Bastelaer 213
280 x 240 mm
In the lower left corner: P. Breugel inv.; in the
lower right corner: Hhondius fecit. cum priv. 1644.;
below, two lines of verse: Als den Mensch' syns
Scheppers goetheyt heeft gesmaeckt, Siet hoe
Ÿdlÿck hy't dan op dese Werlt maeckt.

58 *The Masquerade of Ourson and Valentin,* 1566
Anonymous woodcut, Bastelaer 215
275 x 410 mm
In the lower right corner: 1566 / BRVEGEL.

59 *The Wedding of Mopsus and Nisa,* 1570
After a drawing of c. 1566
Engraving by Pieter van der Heyden, Bastelaer 216
222 x 290 mm
At the bottom towards the left, the monogram of
the engraver; slightly to the right of the middle (in
the first state): H. Cock. excud. 1570.; in the lower

right corner: Bruegel. inuentor.; in the lower margin: MOPSO NISA DATVR, QVID NON

60 *Peasants' Brawl over a Game of Cards*, c. 1620
After a lost drawing by Bruegel or a copy of that drawing by Peter Paul Rubens
Etching and engraving by Lucas Vorsterman, Bastelaer 218
426 x 522 mm
Inscribed lower left: Pet. Bruegel inuent.; on lower margin, printed in six columns, Latin verses by F. A. Reuter, based on Virgil's Eclogues: Tityrus et sterili quondam Meliboeus in agro / Incaluére scyphis, et rixa forte coortà / Caprinam ob lanam, stiua rastroque rigentes, / Conseruére manus, è duro robore scamnum / Cum cyathis volitat, cereuisia tela ministrat. / Hos inter pota plorans cum Baucide Daphne / Et Corydon coecos cupiunt sedare furores. / Vidit Bruegelius, Martem admiratus agrestem / Horridaque exigua descripsit bella tabella. / Cede merum Coum, Cous concedat Apelles: / Nescio quid maius Brabantica rura tulere.; below, signed "F A Reuter" and dedicated, in Latin, to Jan Brueghel, son of Pieter Bruegel: CLARISS. PRAESTANTISSIMOQ. VIRO, DNO IOANNI BRVEGELIO, PETRI BRVEGELII SVI TEMPORIS APELLIS FILIO, PATERNAE ARTIS HAEREDI EX ASSE, HOC PATRIAE MANVS MONVMENTVM ARTIFICIOSISSIMVM, L.M.Q.D.D. Lucas Vorsterman. excud. cum. priuil.

61 *Two Carnival Fools*, 1642
In the manner of Bruegel
Engraving by Hendrik Hondius, Bastelaer 225
130 x 157 mm
Inscribed lower left: P.B. inv. Hh. fecit. 1642. Cum priv.

62 *Three Carnival Fools Playing with Scepters*, 1642
In the manner of Bruegel
Engraving by Hendrik Hondius, Bastelaer 226
128 x 157 mm
Inscribed lower left: Pet: Breug. inv. Hhondius. fecit.; lower center: C: privil.; on the wall date: 1642.

63 *Rascal Without-Pity*
(Schurckje Sonder-Baerot)
Perhaps after lost drawings of c. 1564-65
From the *Suite of Heads of Peasant Men and Women Showing Different Expressions*
Etching attributed to Jan or Lucas van Duetecum, Bastelaer 261, right side
128 x 94 mm
Inscribed lower right: 20

64 *Aecht Without-Soul*
(Aecht Sonder-Ziel)
Perhaps after lost drawings of c. 1564-65
From the *Suite of Heads of Peasant Men and Women Showing Different Expressions*
Etching attributed to Jan or Lucas van Duetecum, Bastelaer 265, left side
133 x 93 mm

65 *A Man Yawning*
After a painting of c. 1564
Etching and engraving attributed to Lucas Vorsterman, Bastelaer 278
209 x 207 mm
Inscribed lower left: Pieter Breughel Pinxit; lower right: Cum Priuil.